JARROW
MURDERS AND
MISDEMEANOURS

NATASHA WINDHAM

AMBERLEY

This book is dedicated to the people of Jarrow, both past and present

First published 2020

Amberley Publishing
The Hill, Stroud
Gloucestershire, GL5 4EP

www.amberley-books.com

British Library Cataloguing in Publication Data.
A catalogue record for this book is available from the British Library.

ISBN 978 1 4456 9786 4 (paperback)
ISBN 978 1 4456 9787 1 (ebook)

Typesetting by Aura Technology and Software Services, India.
Printed in Great Britain.

CONTENTS

INTRODUCTION

Jarrow was a former shipbuilding town, but you already knew that, didn't you? Founded by iron and steel, and close to the River Tyne, it was a bustling hive of industry where ships, paper, chemicals and crimes were often manufactured. It was a town where an outraged editor of the local newspaper, *The Jarrow Express*, once lamented, 'The inhabitants will not stand for it!' after a long list of inebriates had been summoned to the local police court. It was a town where George Heir, in July 1888, had drunkenly thrown turf at the respectable people in the park as a brass band played behind him. It was a town where John Rook, in April 1883, had boldly declared to the magistrates after being arrested for drunkenness, 'You know bloody well an Irishman can take drink any time.' It was a town where rival lodging housekeepers Jane McCabe and Mary Ann Carlisle, in 1883, had assaulted each other on Albion Street after one of them had shrieked, 'Your two fancy men are taken up!'

However, many residents of the town were law-abiding and there's no better way to begin this book than to introduce a man who loved Jarrow. James Dudfield Rose was a chemist, photographer, councillor and local historian. He was well known as an energetic businessman, and was also an enthusiastic member of the camera club. He championed a greater Jarrow for those poorer than himself and in his later years he became one of the most popular men in town.

The Rose family arrived in Jarrow in 1870 while James was still an infant. His father, also named James Dudfield Rose, was an assistant to the police

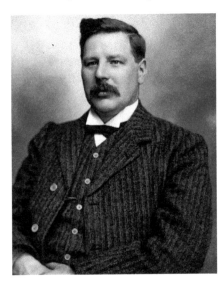

James Dudfield Rose Jnr embarking on his career as a pharmacist in Jarrow. (© Phyllis Claxton and James Rose)

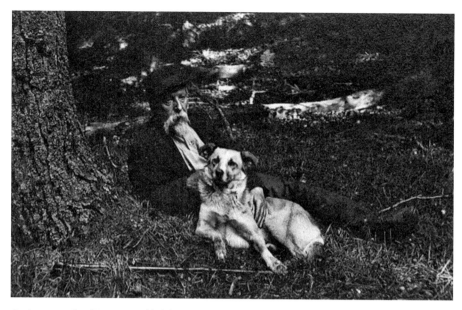

A photograph of James Dudfield Rose Snr, with his pet dog, in Stanhope, County Durham. (© Phyllis Claxton and James Rose)

surgeon Dr Kelly and later became a well-respected druggist and chemist on Ormonde Street. James Jnr followed in his father's footsteps and registered as a chemist in 1892. His first love, though, was photography, closely followed by his blossoming interest in local politics. He ran two successful chemist shops and often diversified to deliver more unusual products to his customers.

James believed a keen interest in reading led to well-rounded minds who sought further education and avoided committing crime. He became an independent councillor in 1899 and campaigned for a free public library to be built. Andrew Carnegie, industrialist and billionaire, wanted to award £5,000 to the people of Jarrow for the library they had long fought for, but the town needed to adopt the Free Public Library Act. Jarrow already had the Mechanics' Hall on Ellison Street, but payment was required to use their classrooms, attend their classes and borrow their books. James understood low-income families couldn't always afford to pay for further education and he was keen to represent them in his campaign to secure a free public library.

As he stood before his audience on the night of 8 June 1899, Rose had charts, graphs and a speech prepared. Even a petition in favour of the free library was delivered by a local priest and signed by 630 of the poorest townspeople. Rose was a determined man and spoke passionately about how a new library in Jarrow could transform the town. He was eager as he produced his research and spoke eloquently to his fellow councillors. 'What more progressive action can we take than this which opens vast knowledge within the reach of all?' he asked them.

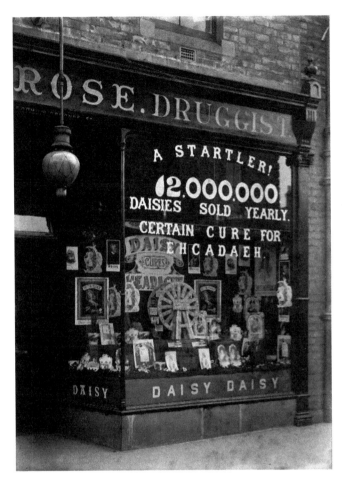

Left: The Rose Druggist shop at No. 1 Bede Burn Road, Jarrow. (© Phyllis Claxton and James Rose)

Below: J. D. Rose Jnr's chemist and seedsman advert. (Source: *The Jarrow Express*, 20 May 1898)

SOW A SHILLING
AND
REAP A POUND

It's a fact! And anyone with a small garden can prove it.

If you have not tried

ROSE'S SEEDS

Go to your neighbour who has and note the results.

APPLY FOR PRICE LIST TO

J. D. ROSE, Chemist and Seedsman,

18, Ormonde Street, and 1, Bede Burn Road, JARROW.

Later that evening, the following members of the council voted in favour of the new library: the Mayor, Aldermans Armstrong and Dickinson, and Councillors Pearson, Rose, Chalmers, Treliving and Casey.

Unfortunately, not every member of the council shared James' vision for the town. Aldermans Handyside, Harris and Penman and Councillors Barrasford, Rutherford, O'Connor, Frew, Lumsden, Johnson, Rupp, Dillon, Reavley and Ramsey voted against adopting the Free Library Act.

The defeat gravely disappointed James because books weren't a luxury; they needed to be available to all classes whether rich or poor. He was still keen to continue his work as a councillor, focusing on public health, and won re-election over the years that followed. As chairman of the sanitary board, he forged ahead with his plans to improve the cleanliness of the hospitals and the backstreets of Jarrow.

On 3 June 1935 he stood before his fellow councillors and townsfolk as he read a speech written to commemorate the Diamond Jubilee of the borough of Jarrow. As articulate as ever, he spoke to his captivated audience and shared

J. D. Rose Jnr's re-election poster, dated 1901. (© Phyllis Claxton and James Rose)

SUPPORT HOME INDUSTRY.

If you want a Bicycle

RIDE

A "PALMER,"

MADE IN JARROW.

SOLE AGENT—

J. D, ROSE, 18, Ormonde Street.

Support home industry and buy a Palmer bicycle today. (Source: *The Jarrow Express*, 26 March 1897)

a story from Jarrow's past. 'Shortly after I became chairman, I smothered one unpleasant incident which had it leaked would have supplied our press with reams of "Good Copy" ... It was this: One Sunday morning I paid a surprise visit to the hospital and not having much confidence in our resident porter – I always wanted to see things for myself and asked awkward questions. On this occasion I wanted to see inside the mortuary – a part of the building seldom required. The porter assured me it was alright, but he was sorry he hadn't the key. I told him I would accept no excuse and into it I would go and after much trouble I did get in and to my horror discovered a pigsty with two or three live pigs inhabiting the deadhouse!'

A true friend of the working classes, Rose immersed his mind in researching the Venerable Bede and was well respected in the community. He was a learned man with a passion for knowledge and truly embraced his adopted home. His decision to always bring diagrams and evidence of his findings to council meetings often offended his regressive counterparts who were unable to contain their frustrations towards his progressive nature. He was, in fact, considered radical at the time due to his ambitions to revolutionise the sanitation of the town and help the less fortunate. Comfortable in life and happily married, he often read *The Jarrow Express* and as an enthusiast of local history would surely have heard many of the following tales.

WHERE'S YOUR HUSBAND?

A Jarrovian once described their town as the wild west of the North East. Brawls, fights and scuffles would spread like wildfire on the streets of Jarrow. Drink would be drunk, assaults would be committed, and the police would often be attacked in the line of duty. Women would violently squabble over who used the washhouse first, men would hurl their coats to the floor and trade vicious blows, and those known as the respectable people of the town would preach, judge and grumble. Their stories have been borrowed from the pages of the past and it all begins in 1877 with the fabulously named Constance Crow.

Constance was a woman plagued with marital problems, light fingers and a thirst for drink. She was married to coal dealer John Crow, who had experienced his own brushes with the law. Constance, though, was the queen of theft and her own husband was her most frequent victim. Perhaps she learned the flourishing trade of larceny from him? In March 1877, the police arrived to search the Crows' home. They recovered a large haul of stolen items, including feather pillows, blankets, table linen and sheets. When asked who had pilfered them, Constance replied, 'My husband brought them home.' They had been stolen from Palmer's own screw-steamer *Swiftsure*, which was docked in the River Tyne. John, with the help of the night watchman aboard the ship, had taken the stolen goods ashore in the middle of the night and was subsequently sentenced to six months in prison with hard labour.

Twelve months later, it was a respectfully dressed Constance in the dock at Jarrow with the magistrates casting disapproving looks her way. She had been discovered

The River Tyne from Jarrow. (Source: Natasha Windham)

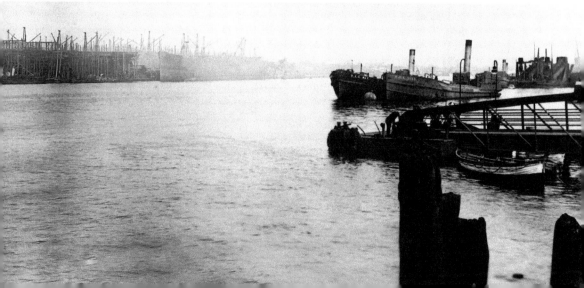

drunk and incapable by PC Applegarth on Albert Road. As she lay on the pavement in the early hours of Sunday morning, the police constable had failed to pry any sense from her. Even asking a question such as 'Where do you live?' fell flat, and he took her into custody. As she admitted the charge of drunkenness to the magistrates at the police court on High Street, she promised to remain sober if they were lenient with her. She was fined 2s 6d and then dismissed from court.

Constance, though, could often be found where trouble brewed. Seven days later, on 8 March, she was once again summoned to Jarrow Police Court. This time it was to testify about a vicious assault she had witnessed on Walter Street. Sarah Beith was the victim. Henry Beith was the perpetrator. Frightened of her husband's short temper and aggressive behaviour, Sarah had fled the house with her shawl. For hours she walked the streets and eventually returned home at 11 p.m. As soon as she entered the house her husband attacked her. As she tried to flee once more, he threw a salt cellar at her head and hurled a basket at her retreating form. The dish left a vicious gash on her forehead, leaving her stunned and dazed for a moment. Henry seized his chance and hurled his wife on the bed, striking her repeatedly in the face with a fist.

Two police constables were patrolling nearby as they heard a cry of 'murder!' in the night. They sprinted to the scene and found the door locked. As they considered breaking it down, another resident of the house opened it, and they burst into the Beith's bedroom. Sarah was bloodied and barely conscious as her husband continued his assault. The officers rushed forward and dragged Henry off his stricken wife.

Standing before the bench, a frightened Constance repeated she didn't wish to be involved in the case. The magistrates, though, threatened her with gaol if she didn't speak. Finally, she admitted to witnessing part of the assault.

Albert Road, Jarrow, Christmas morning, 2019. (© Ewen Windham)

Walter Street, Jarrow, December 2019. (© Ewen Windham)

Henry denied attacking his wife and said he had only pushed her because she had been drunk, but the day following the assault Sarah had visited a doctor and had been so badly beaten by her husband she struggled to walk. Though the bench viewed the case as serious, they merely fined Henry 20s and costs.

It was now 1881 and Constance had her own violence to endure. Again, the month was March and at an address on Queens Road she was living with her husband John. On the night of the 23rd, John had returned home in a drunken state. Wearing a pair of heavy boots, he kicked Constance and struck her too. He denied the charge and complained to the magistrates that his wife had stolen his clothes and pawned them. Constance, however, said she was scared to live with him. John was bound over to keep the peace for six months and warned if he was violent again, they would grant a separation order.

Four months later, Constance stood accused of assaulting Bessy Bryson. They were neighbours who shared a yard. As they had held a lively debate over whose turn it was to use the washhouse next their disagreement ended in a cascade of violence. Constance threw a poss stick at the wall and was also accused of striking Bessy across the head with a brush and using an iron poker as a weapon. Constance had denied the charge and bitterly complained about her clothes being thrown about the yard by Bessy. Still, Constance was fined 5s and costs.

In May 1882, Constance was once again charged with drunkenness, this time on Queens Road. She refused to answer the summons and was fined 7s 6d in her absence or seven days imprisonment. Two more charges of drunkenness in 1885 were upheld against Constance. Another charge of drunkenness followed suit in 1890. March was an unlucky month for our heroine and in 1891, on the last day of the month, Clara Bainbridge was accused of pouring a pail of water over Constance. Clara was fined 5s and costs for her loss of temper.

The year 1894 was one Constance wouldn't forget. In April she was charged with stealing her husband's clothes and pawning them without his knowledge.

When John left the house, he noticed Constance loitering in the backyard. Thinking little of it, he went on his way, but once he returned home he discovered clothing missing. He instantly knew his wife was to blame. Constance, meanwhile, had walked to William Hoppers' pawn shop and sold him a pair of trousers. He asked who they belonged to and Constance had answered, 'my old geranium'. This signalled another court appearance for her. *The Shields Daily Gazette* described Constance as an 'elderly woman' when she stood trial – anybody over the age of thirty-nine should be mildly concerned as Constance was estimated to be in her mid to late forties at the time. She took offence at being placed in the dock and blamed her husband for her current predicament. Stating it was all his fault, she said he was only doing this to 'get rid' of her again. John denied this and, with Sergeant Fleming's encouragement, the magistrates sentenced Constance to four weeks in Durham Gaol.

The swift arm of the law wasn't far behind Constance in late October of that year and her fingers were lighter than normal. She strolled rather brazenly into the lobby of the stationmaster's office at Newcastle Central Station and stole a large bundle of clothes and a coat. She sold the clothing to general dealers on Pilgrim Street then returned home to Jarrow. Hours later there was a loud knock on the door. She was arrested after a coat belonging to the North Eastern Railway was found in her home. She had been in the middle of defacing the branding marks on the coat when the police had arrived. Found guilty at Newcastle Police Court, a two-month prison sentence was awaiting her.

After her release from prison she disappeared for the whole of winter. She resurfaced again in Jarrow in May 1895. Her husband hadn't minded her absence as he had grown tired of her craving for theft and beer. At half eight on a cold evening he went to his coal house in the backyard of No. 56 Lord Street. He suddenly noticed his drunken wife entering the yard via a gate. When she saw him, she left quickly but he soon missed his coal shovel and several items of clothing. An exasperated John wanted his belongings returned and reported his wife to the police.

'Is she living with you?' the chairman of the Jarrow Police Court asked.

'She has been for the last days only,' John admitted.

'I was obliged to go away,' a weeping Constance told the court.

The chairman sighed. 'It was all the drink, Mrs Crow.' He then turned to John. 'Do you wish to press the charge?'

'I would overlook it if she would promise to be teetotal. She is a good woman when she is sober, but if she gets any drink, she takes all that she can lay her hands on and goes off,' John said.

Considering the testimony, the magistrates sentenced Constance to one month in prison. She was to be separated from her husband once more and many would presume that this time Constance had learnt her lesson. However, her relationship with alcohol was growing stronger as each day past. By 1897, John Crow was living on Percy Street, Jarrow.

His wife flittered in and out of his life, often taking his clothes with her. In September of that year Constance was once again charged with stealing her

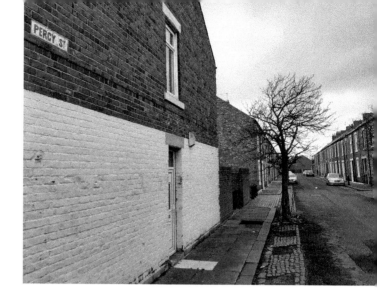

Percy Street, Jarrow,
December 2019.
(© Ewen Windham)

husband's belongings. She had even taken one of his chickens, but he saved it before it was sold. Constance informed the magistrates she would rather be dealt with by them because her husband was always locking her away. She said she was starving of hunger and complained he wouldn't feed her. The magistrates sent her to Durham Gaol for one month with hard labour. The disapproval of the court wasn't Constance's only worry. In June 1899, a correspondent from *The Jarrow Express* wrote, 'Constance Crow has 28 days durance vile at Durham, at the expense of the British public, in which to reflect on her bad conduct. May the reflection be of a beneficial nature.' Even the public were growing tired of her behaviour, but they failed to comprehend a substance abuse problem could often bond firmly to sudden spates of criminality.

Women were often said to be calmer than the opposite sex, but Alice Laffey was about to fearlessly trample across that belief with weapons drawn. Twenty-nine-year-old Alice, with her lodger Annie Cunningham and friend Elizabeth Kelly, were not to be trifled with. In late May 1881, two bailiffs named William had knocked on Alice's door and whatever upset occurred left the men running for their lives. Following close behind were Alice and her right-hand women armed with a poker, a frying pan and a child's chair. They chased William Robinson and William McFarlane along Stanley Street and must have felt liberated by their actions, although the police took a dim view of their behaviour. Alice and Elizabeth were fined 5s and costs, with Ann escaping any punishment.

Not to be outshone, Mary Ann Cooney was a woman gifted with quick wit and a sharpness of tongue. Of Scottish origin and fiercely independent, she was a prostitute labelled by Superintendent Fleming as 'one of the worst characters in town'. Described as 'good looking' and 'very vixenish', she drank her way across Jarrow, clashing with many and eventually succumbing to alcoholism. In Jarrow Police Court in 1882, Inspector Snowdon said, 'It took four policemen to bring her to the station.' Mary Ann swiftly responded, 'It will take six next time.'

Many Victorians underestimated the mysterious mind of a woman. Without the right to vote, they were considered the weaker sex. The women, though, didn't always parade to *that* tune. Some were wallflowers, others were hellraisers,

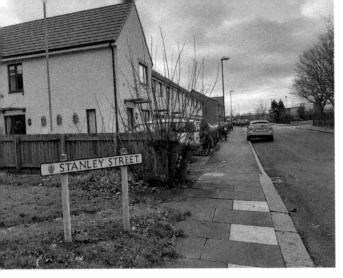

Left: Stanley Street, Jarrow, October 2019. (© Ewen Windham)

Below: Mary Ann Cooney was often arrested for being drunk and disorderly on Grange Road. (Source: George Nairn)

Grange Road, Jarrow on Tyne.

and many just wished to rule their own worlds and live comfortably in sin. Alice Laffey rebelled against any notion of being a shrinking violet. Constance Crow wrestled her demons one lonely step at a time. Sarah Beith, at least for a short period, broke free of her violent husband's grasp. While Mary Ann Cooney, helplessly dependent on alcohol, frantically pleaded for support from the authorities. The working-class women of the nineteenth century were warriors dressed in plumes of fabric. They fought their battles and *you* are residing proof of their victory.

I HAVE BEEN SILLY

Isabella Brewis was born in Newcastle upon Tyne in 1842. She was the daughter of John Brewis and his wife Catherine. In 1864, Isabella, aged twenty-two, married Prussian-born Paul Thomalla. He ran a successful butcher's shop at No. 94 Ormonde Street and was known as the 'original pork butcher of Jarrow'. Fairly affluent, they could afford two servants. By 1875 they were now a family of seven, but Isabella was unwell. She had been suffering from headaches for many years and couldn't help her husband in the family-run butcher's shop. He had complained to her about her inability to support him with his business and this made her feel as though she was neglecting her duties as a wife.

Catherine, Isabella's mother, had recently arrived in Jarrow to stay with the family and help look after the children. Eager to improve her daughter's health, she had sent a phial of hartshorn ahead of her arrival to help treat the headaches. Hartshorn was a form of ammonia. It was efficient at removing stains and was also effective at treating fevers and sunstroke, but it wasn't to be used as Isabella intended.

On Saturday 17 April, early in the morning, Isabella felt worse than normal. The phial of hartshorn was kept on top of the cupboard in her bedroom. As her

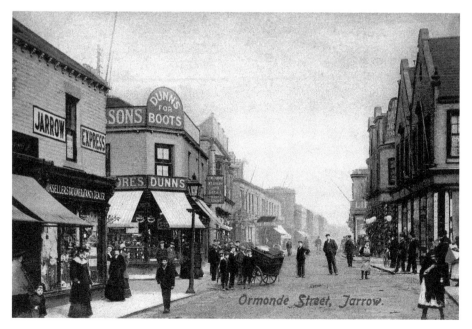

Ormonde Street, Jarrow, was once a shopping destination bustling with trade. (Source: George Nairn)

family slept, she drank half the liquid in the vial and collapsed. At 6 a.m. her distraught mother found her, and a frightened Paul rushed to be by his wife's side. The family sent for Dr Huntley and when he arrived, he immediately diagnosed his ailing patient and seized upon the phial of hartshorn labelled 'poison'. Isabella was overcome with violent retching and vomited bloodied mucus, and as she suffered, Dr Huntley questioned her. Had drinking the toxic substance been a deliberate act? Isabella nodded her head.

The following day, a heartbroken Paul asked his ailing wife why she had swallowed the poison. Isabella couldn't speak because her throat was severely inflamed, so they brought a slate and piece of chalk to her bedside. 'I am so sorry I have not been able to help you in the shop, but my head was so bad. I have been silly,' she wrote. Her condition gradually deteriorated and on Monday 19 April she passed away.

On Tuesday afternoon, a day after thirty-five-year-old Isabella's untimely death, an inquest was held at the Railway Inn, Jarrow. Dr Huntley described Isabella as a 'weakly woman' who had turned to drink to help overcome her issues and spoke of once scolding her for using brandy as a crutch. In Dr Huntley's opinion, Isabella's death was due to self-inflicted poisoning because she had been plagued by thoughts of drinking alcohol. The people of Jarrow were incredulous by the slanderous claims against Isabella, and rumours swirled across the town.

Isabella's funeral, held on the afternoon of Wednesday 21 April, was described as 'one of the most disgraceful proceedings ever witnessed in Jarrow' due to the

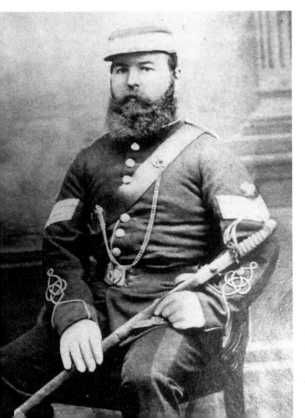

The original pork butcher: Paul Thomalla. (Source: Trevor Hay)

behaviour of the townspeople. They had believed the unfounded rumours surrounding Isabella's demise and on the morning of the funeral service a mob began to form on Ormonde Street outside the Thomalla residence. By 2 p.m. the crowds had grown to thousands and as the hearse arrived, the people of Jarrow made their feelings known to Paul Thomalla. Rotten fruit and vegetables were thrown at the mourning carriages and the police had to firmly guide the grieving widow from his home as several members of the crowd attempted to attack him.

As Isabella was buried in section E of Jarrow Cemetery the crowds attempted to storm through the gates. Further members of the police force were dispatched to keep the unruly and vengeful mob from causing further harm to the visibly grief-stricken Thomalla. The journey back to Ormonde Street was just as perilous for the mourners. The police were forced to clear the streets to keep the family unharmed, but as soon as Paul entered the safety of his home the crowds began to disperse, and normality resumed.

Unfortunately, Paul Thomalla's business couldn't survive the negative hysteria whipped up against him. He had been blamed for the death of Isabella and was unable to salvage his crumbling reputation. Remarrying later that year, he eventually emigrated to South Africa. He passed away in 1917 in Johannesburg but will always be remembered as the original pork butcher of Jarrow.

Jarrow Cemetery, October 2019. (© Natasha Windham)

ESTABLISHED 1863.

PAUL THOMALLA,
THE ORIGINAL PORK BUTCHER,
94, ORMONDE STREET, JARROW.
Finest Quality of Dairy-Fed Pork, Home Cured Bacon, Hams and Lard, Best Cambridge Sausages fresh every day:

An advert for Paul Thomalla's butcher shop. (Source: *The Jarrow Express*, 1876)

Jarrow Cemetery, October 2019, (© Natasha Windham)

SHE IS SOMEWHAT QUIETER, HE IS EVIDENTLY SUFFERING

'What do you have under your jacket?' Inspector Harrison had asked. Catherine Cardell, a dark-haired woman with the most vacant of brown eyes, paused on High Street and gazed at the inspector. It was Sunday 20 June 1880. Under her jacket was a cement bag she had taken from the side of the road. It was a similar sack to those that workmen would use to protect freshly laid cement. It was just a sack, but this was Victorian Britain.

Mother of two, Catherine, told Inspector Harrison she had nothing that didn't belong to her. He didn't believe her and searched her where she stood. When he discovered the stolen item, he arrested her and escorted her to the police station. An investigation was launched and witness statements were gathered.

The next day, Catherine was taken to Jarrow Police Court and charged with theft. A young girl named Mary Ramsay appeared for the prosecution and admitted she had seen Catherine steal the sack. The prosecutor, Mr W. Young, stated his client wouldn't have missed the item had they not informed of the theft. Still, they continued with their case against Catherine Cardell.

The minor magistrates on the bench (including the Mayor, Alderman R. E. Huntley, and Alderman Dickinson) asked Catherine where her husband was. She told them he was working in the shipyard. Her eldest son, William,

High Street, Jarrow, October 2019. (© Natasha Windham)

who was just shy of thirteen, raised his hand and told the court his mother was lying. His father, he said, was in an asylum.

William was invited to sit in the witness box and answer several questions about his home life. He told the court his mother drank heavily and sold the furniture to fund her habit. He earned 6s per week under his current employment, but rarely worked a full week. He spoke of his brother Charles, who was six years old, and asked the court if they could help care for the young boy.

The Jarrow Express quoted Catherine as the 'Prisoner, who seemed quite stupid, said the boy was telling the truth.' The bench sentenced Catherine to one full month in Durham Gaol, and they informed William they would help care for his younger brother. In fact, they would send Charles to the workhouse, and then William could work without any intrusion.

William, however, had been incorrect. His father, Thomas Cardell, was still being held in the infirmary at South Shields Workhouse. They admitted him to Durham Asylum on the 21 July 1880. Forty-five years of age, Thomas was a former soldier who had first met Catherine in Chatham, Kent. Their two sons had been born in Chatham and Aldershot, and once discharged from the army, the family had moved to Jarrow in search of a brighter future.

The family's sparkle of hope had long since diminished. With his hair dark, his eyes grey and his gait feeble, Thomas sat in the lodge at Durham Asylum on the first day of admittance. One of his most worrying symptoms was the frequent removal of his clothing and his naked walks in the garden. After several schoolchildren had seen him unclothed, Thomas had been sent to the workhouse. Even they struggled to care for him, and he was later removed to the asylum. As the doctor performed an examination, he found the pale Thomas had previously fractured two left ribs that had healed poorly. He had crowded yet healthy teeth, good hearing, his lungs sounded strong, but he had a muscular tremor and uncertain movement. He was unable to answer questions put to him and considered silent yet often restless. Thomas Cardell was suffering with general paralysis of the insane.

General paralysis, or to use its modern name, neurosyphilis, was a serious illness that destroyed the mind and body of the sufferer. Unpleasant in its nature, it eroded the functions of the brain, caused personality changes and could trigger acts of antisocial behaviour. In later stages, patients were unable to walk, and became bedridden as they wasted away while suffering from depression, hallucinations and pain. When syphilis was left untreated it could cause symptoms akin to dementia. The last stages of the disease would spread to the brain and leave the patient unable to function. It was a devastating diagnosis and a certain death sentence.

Catherine, meanwhile, had served her prison sentence and returned to Jarrow. There was to be no happy homecoming for her, and she was admitted to the South Shields Workhouse in early August 1880. At thirty-four years old, the staff deemed her behaviour dangerous to others, and she joined her husband at Durham Asylum.

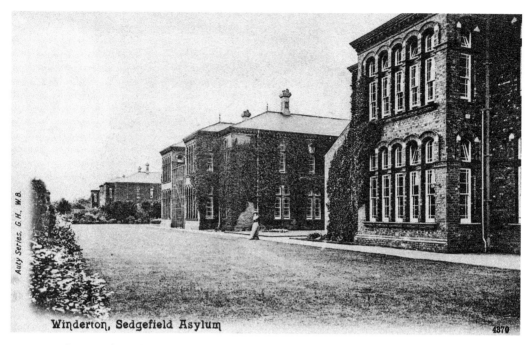

Durham Asylum, later renamed Winterton Hospital, in Sedgefield, County Durham. (Source: George Nairn)

She had torn her clothes and bedding to ribbons, assaulted nurses and other patients, and on 9 August she sat in the lodge wearing a straitjacket and accused of wearing a 'stupid and demented' look on her face. Catherine was also suffering from general paralysis of the insane.

By the 15 August, Thomas was reported as becoming more restless, noisy and being prone to wandering aimlessly at night. His wife wasn't fairing any better. Catherine's eyes were dull and heavy, and she passed urine in the bed. She was unable to identify anybody, her language was disjointed and difficult to understand, and she was terribly violent and shrieked coarse and insulting words. In early September, Thomas' condition had begun to weaken, and he was now bedbound as sores and abscesses erupted on his skin. His pulse was weakening by 7 September and dry dressing was wrapped over his broken skin. Two days later, the doctor remarked of Thomas, 'he is evidently suffering'. Thomas Cardell died in Durham Asylum on the 9 September 1880 as his wife continued to deteriorate.

By 28 November, Catherine had attacked the patient in the adjoining bed and tore the hair from the woman's head. She was put in a single room and kept in bed. Though feeble, she continued to have violent tendencies. On 10 Friday December, at 3 a.m., Catherine was discovered in a weakened state with a thin pulse. 'She is somewhat quieter,' the doctor remarked. Catherine passed away several hours later at 5 a.m.

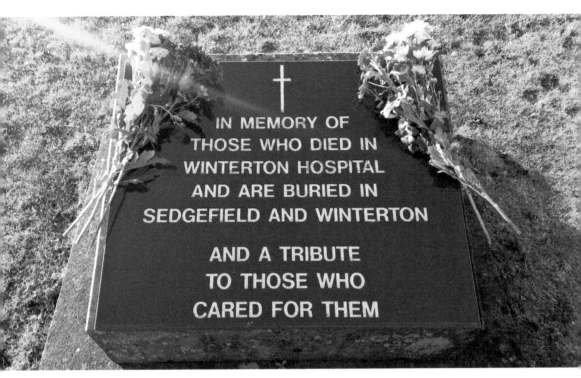

IN MEMORY OF
THOSE WHO DIED IN
WINTERTON HOSPITAL
AND ARE BURIED IN
SEDGEFIELD AND WINTERTON

AND A TRIBUTE
TO THOSE WHO
CARED FOR THEM

A remembrance plaque for all those who perished at Durham Asylum. (© Natasha Windham)

Now orphaned, William and Charles Cardell were both living in South Shields Workhouse. In a further cruel blow to the family, William died, leaving Charles alone. Eventually, the young boy went to live with his grandmother in Huntingdonshire. After several run-ins with the law because of theft and handling stolen goods, Charles married and became a father of three. In February 1939, he was bicycling home and had reached the top of his street when a vehicle struck him, and he was thrown from his bike. His wife had witnessed the collision, and Charles later died of his injuries.

It all began with a stolen cement bag, but ended in tragedy for Thomas, Catherine, William and Charles. The Cardell family's story was extraordinary in its cruelty and sorrow and proved that sometimes the simplest of stories can become the hardest of tales to tell.

OH MAGGIE, SPEAK TO US

Margaret 'Maggie' Giblin was born in Gateshead in 1867 to Scotsman James and his South Shields-born wife Rose. From the age of four Maggie was raised in Jarrow while her father laboured at the local chemical works. On 13 February 1883 Maggie married Michael Kirkwood at St Bede's Church. Michael was a ship riveter, born in 1862, who had worked up and down the Tyne for many years. He coasted from job to job and his birthplace changed from one record to the next, but the most common birthplace provided was Hartlepool. There was something a little dark and unusual about Michael's character and unfortunately the newlyweds' happiness wouldn't last.

The marriage between Michael and Maggie produced one daughter – a girl named Mary, who was born in the winter of 1883. As the months passed cracks began to appear in the marriage and Maggie moved back to her parents' home in early 1886 for the dozenth time.

Michael was distraught after his wife had left him. In May of 1886 he tried to win her back and when that didn't work, he visited the local Jarrow police station and pleaded with a constable to accompany him to find his wife and help bring her home. The constable declined the invitation and told Michael to go home and think about treating his wife with more kindness instead. Michael didn't have a home, though. He had been lodging at a house in Stanley Street. He missed his family and was determined to make his wife see sense.

On the fateful day, Maggie bought wool from a shop on Ormonde Street, Jarrow. (Source: George Nairn)

On the afternoon of Monday 24th, Maggie had walked from High Street to Ormonde Street to buy her sister some wool. She was returning home when she saw her husband on Stanley Street. Michael approached her and stopped her from walking by him. They began to argue, and Michael held out his hand and demanded she give him one and a half pence for tobacco. Maggie told him he couldn't have the money and then she swore at him. In a blind rage Michael clenched his right fist and struck Maggie in the face. She collapsed and her forehead landed with a sickening crack on the curb. 'Oh dear,' were the last words Maggie would ever utter.

Michael crouched down beside his lifeless wife and whispered to her, 'Oh Maggie; speak to us' as neighbours gathered around them. He picked up his wife and carried her into No. 47 Stanley Street, where they once lived, and laid her on the bed as he once again pleaded for her to wake up. He left the house and beckoned for a neighbour to follow him back inside. The shocked neighbour told Michael that Maggie looked 'quite dead'.

Michael left the house and was about to leave the street when he saw Maggie's younger brother James Giblin. James had heard rumours about his sister being harmed and he was carrying a stick in his hand and a brick in his pocket. Michael said to James, 'You had better stop away. If you come out here, I will serve you the same.'

Inspector Snowdon arrived within ten minutes of hearing news about the death. Dr Nairn Lee was already at the scene and had pronounced Maggie deceased. An autopsy showed Maggie had died from a fractured skull and blood was found pooled in the base of her brain. There was a mark on the left side of her forehead, a cut upper lip and her face was littered with bruises. Maggie was dead and Michael Kirkwood was now a wanted man.

After leaving the scene of the crime, Michael had visited his sister's home at No. 18 Princess Street. His sister, Mrs Barrett, was horrified when her brother told her what had happened. Michael was beside himself and threatened to

Stanley Street, Jarrow, December 2019. (© Ewen Windham)

'make a hole in the Tyne'. He had tears in his eyes as he said to his sister, 'Oh Bridget, I have hit Maggie and they say she is done. Let me through to your house.'

His sister Bridget stepped outside and saw Maggie's brother James watching from the road. She rushed to No. 47 Stanley Street and viewed the body of Maggie. Horrified, Bridget ran home and found her brother standing in the kitchen. 'What have you done?' she asked before fainting.

As the Jarrow rumour mills swung into production, tales were spread by people claiming they had seen Michael down by the boat landing on the Tyne. Those rumours proved to be false because later that night, he was arrested at a house on Albion Street. Michael appeared calm and was smoking a pipe when he was taken into custody. As crowds gathered outside, he was led to the police station and he gave a long and rambling statement which the police refused to release to the press.

The next morning, Michael appeared at Jarrow Police Court charged with the murder of his wife. He was described as 5 feet 7 inches in height, compact in build, had a black eye, a large nose and was wearing scruffy clothing. As he stood in front of R. Handyside Esquire, Supt Scott spoke: 'This man, your worship, is charged with the wilful murder of his wife, Margaret, yesterday afternoon in Stanley Street. It appears his wife and him have not been living on the best of terms for some time past, and yesterday he met her in the street and asked her for one and a half pence to get some tobacco and beer with. Upon her refusing, he struck her a violent blow on her face and I have reason to believe her skull was fractured by the fall, which caused instant death. After hearing the evidence of the officer who apprehended him, I have to ask you for a remand until Thursday when very likely the case will be gone into.'

'Me and her were up the street; we were up the street together', Michael said, trying to explain what had happened between him and Maggie.

Handyside abruptly interrupted him. 'You had better not say anything here.'

While Michael was moved to a more secure location in Durham, Maggie was buried in Jarrow Cemetery on Thursday 27 May 1886. The weather was atrocious and kept large crowds from forming. Several women formed a sombre

Maggie's unmarked grave at Jarrow Cemetery. (© Natasha Windham)

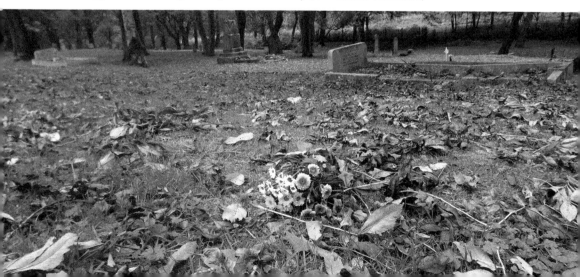

procession and followed the remains of Maggie to the cemetery. Only a modest group of people stood on the corner of Monkton Road to witness Maggie's coffin pass them on the way to her final resting place.

Michael's trial began in Durham on the morning of 17 July 1886. His charge was reduced to manslaughter and the witness statements were heard over several days. Michael swore he hadn't struck his wife with any bad intention and the trial ended on the 20 July. He was sentenced to six months imprisonment for the manslaughter of Maggie.

Once released from prison Michael would kill again. In 1889 he was accused of causing the death of David Stevens in High Street, Sunderland. Michael had been causing a nuisance of himself and kicking the door of the Globe Pub when he had exchanged words with Stevens. Michael was described as a 'strange man' as he called his victim 'a pig' and violently punched Stevens in the abdomen, causing catastrophic injuries.

When issuing the warrant for Michael's arrest, the local judge said he had heard the accused was from Stockton. 'Stockton?' a witness commented. 'No, I've known him for several years and he comes from Jarrow.'

Now remarried, Michael was arrested in Hartlepool and once again charged with manslaughter. He served a further eight months in prison for David Stevens' death. On the 24 November 1900, Michael was admitted to Durham Asylum. He was described as violent, delusional, maniacal and threatening. He had to be contained in a straitjacket until he calmed down. He claimed two men were outside the door and that during the night one of them had stabbed him in the leg, though no evidence of injury could be found. His violent conduct continued

Inside 'A' block at Durham jail. (Source: George Nairn)

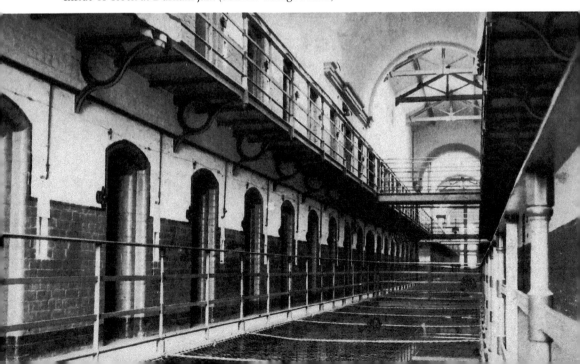

and although a special attendant had been watching him, he still managed to escape through a window and climb onto the roof. Eventually a policeman was sent for and brought him down to safety.

The unstable Michael was suffering from paranoid delusions and was convinced two men on the ward were armed, dangerous and shooting a revolver at him. By 30 November, he had jumped through a plain glass window and sustained slight injuries. Throughout the month of December, he was still threatening members of staff at the asylum but was becoming more manageable.

By January 1901, Michael had accused the attendants of putting faeces in his trousers to dirty them. There was no change in his behaviour by April. On 14 July he declared he was dying and pleaded with a doctor to examine him. He stated he was 'full of pins and needles' and wasting away. There were no changes in his behaviour by September. In December he was still abusive and suffering from delusions.

Throughout 1902, Michael showed no signs of improvement. By 1 October 1903, Michael was reported as being able to hold pleasant conversations for a short period of time but suffered under acute delusions. Durham Asylum was still Michael's home in 1905, where the doctor described him as troublesome. He could often be observed looking over his shoulders when walking to check if people were throwing objects at him. He continued to be paranoid and believed people wished to harm him.

In April 1906 Michael told his doctor he was hearing voices bellowing in his mind. He had outbursts of excitement but had periods of quietness too. In September, he said he lied about hearing voices. He was a man overwhelmed by his psychological instability and was soon battling the physical symptoms of pulmonary tuberculosis. Mentally, he may have been suffering from schizophrenia in a time when mental health treatment was in its infancy. He would never regain his freedom and passed away in Durham Asylum on the afternoon of 18 July 1907.

The site of Durham Asylum in the present day. (© Natasha Windham)

MY GOOD GOD, TOM

Thomas Scott was born on the banks of the River Clyde in Greenock, Scotland, in 1855 to parents Robert and Jane. The Scott family moved to Jarrow when Thomas was still a child. Eventually, he was employed at Palmers Shipyard as a 'plater'. It was a skilled job and consisted of placing plates of steel across the hulls of ships. The challenging and arduous task of ship iron plating would eventually lead to an accident at work that would change Thomas' life forever. On 23 April 1887, Thomas married a servant named Janet Anderson at St Mary's Church in Tyne Dock, but their happiness didn't last. Soon afterwards, Thomas suffered a head injury after falling down a ship's hold at Palmers and this triggered a recurrent illness that ultimately devastated his and Jessie's world.

Since his accident, Thomas had been patient at Jarrow Memorial Hospital on Clayton Street, and Janet, known as 'Jessie' to her friends and family, had continued working as a maid. On the morning of 8 June, Thomas escaped from the infirmary and returned home to his wife at No. 34 Ellison Street.

Mary Ann Davidson, who lived in the upstairs room with her husband, was in the washhouse in the backyard. She heard raised voices coming from the house and a cry of, 'Murder!' As the unsettling shrieks grew in ferocity, she walked toward the house and was joined by her concerned neighbours. As they entered the kitchen what they discovered horrified them. They found Thomas in a violent frenzy as he held a poker in his hands. On the floor lay his unconscious wife, Jessie, in a pool of blood. Thomas' grip tightened on the poker and he continued to strike his lifeless wife across the head. The appalled neighbours dragged him away from the injured woman.

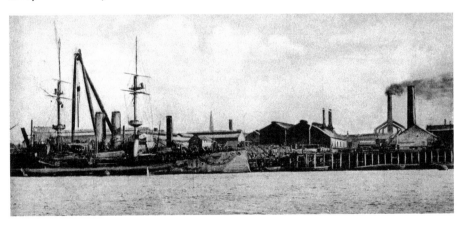

Palmers Shipyard across the River Tyne. (Source: Natasha Windham)

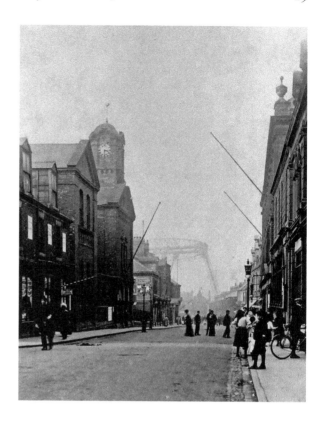

Ellison Street, Jarrow, the home of Thomas and Jessie. (Source: George Nairn)

'My good God, Tom, what have you done that for?' Mary Ann asked with a trembling voice.

The police and doctors were sent for, and doctors Bradley and Whamond and Inspector Snowdon, Sergeant Jackson and three constables rushed to the scene. Thomas was in a fit of rage and despite him only being 4 feet 11 inches in height and weighing 8 stone, it took two burly police constables to hold him down. Before the policemen had reached him, he had attempted to cut his own throat with a table knife, but his wounds were only superficial.

Swiftly, the doctors went to Jessie's aid and carried her to the bed. They then dressed her twenty separate wounds on her head, face, arms and hands. Her condition was severe and the doctors were extremely doubtful she would survive. As people gathered on the street, the police escorted Thomas to a waiting horse and cab, and he was transported to the local police station.

The following day the magistrates at Jarrow Police Court charged Thomas with attempted murder. Superintendent Scott, no relation to the accused, applied for Thomas to be remanded in court for eight days, which was granted. One week later Thomas was once again brought to the local court to answer to the charge. The magistrates, which included Dr Bradley, oversaw the proceedings. Superintendent Scott stated that Jessie was still too unwell to appear in court, and Thomas' solicitor, C. W. Newlands, proposed an order be granted to release the

prisoner from the cells because it was unfair for him to be kept in such a place for too long. Dr Bradley stated Thomas was in a poor condition, nervous and couldn't sleep in the cells. He suggested Thomas should be sent to Durham Gaol for the time being, which was agreed unanimously.

In mid-July, Thomas appeared at Durham Assizes to stand trial for 'feloniously wounding Jessie Scott, his wife, with intent to kill and murder her at Jarrow'. Evidence was produced in detail to show that Thomas had been in a low state of mind since losing his employment at Palmers Shipyard due to his accident. No conclusion could be reached to explain why he had attempted to murder his wife, but Dr Bradley stated Thomas wasn't responsible for his actions because he was suffering from an illness of the mind. However, the Durham County Gaol surgeon, Dr Treadwell, had spoken to Thomas for ten minutes and concluded that the accused was of sound mind. After deliberating for a short time, the jury returned a verdict of 'guilty of cutting and wounding with intent to do grievous bodily harm, but that at the time the prisoner was insane, so as not to be responsible for his acts'.

Under the direction of the judge, Thomas had been ruled to be a 'criminal lunatic' on 12 July 1887. Four days later a warrant of removal arrived at Durham Gaol ordering Thomas' removal. He was to become an inmate at the infamous Broadmoor Asylum in Berkshire. His admission papers stated Thomas was aged thirty-two with a fair complexion, grey eyes, dark brown hair and two scars on his head from his fall down a ship's hold.

SIR,—We desire to make known our sincere thanks to Mr J. Oswald Davidson, solicitor, of Jarrow, for the great pains he took in defending our brother, Thomas Scott, who was charged at the Durham Assizes with attempting to murder his wife. Mr Davidson was only instructed on Friday last, and the Assizes commenced on the Monday following, but he took every means to secure a favourable verdict for our brother, and he must have worked very hard to be ready for the Monday morning, and we are thoroughly persuaded that it is owing to the care with which he prepared the defence and the ability of the counsel, Mr C. W. M. Dale, whom he instructed, that our brother was held not accountable for the acts which he committed, which verdict, we are sure, will commend itself to the public generally. We also wish publicly to acknowledge the gratitude which we feel towards Dr. Bradley, who without being summoned, acceded to the request of Mr Davidson and attended on two days at Durham to further the ends of Justice, which most certainly would have been defeated had he not been called, as will be seen from the remarks of his Lordship, Mr Justice Manisty, who censured the prosecution for not having called Dr. Bradley as a witness, and has allowed him all his costs for attendance on behalf of the defence. And we have to also thank those gentlemen who interested themselves to ensure our brother's defence, which we could not have done for want of means.

Trusting you will excuse our taking up a portion of your space, but we felt anxious that our gratitude should be publicly expressed.—Yours, &c.,
THE BROTHERS OF T. SCOTT
Jarrow, 14th July, 1887.

High praise from the Scott brothers. (Source: The *Jarrow Express*)

By September 1888, Jessie Scott had miraculously survived her injuries and was praying for her husband's release. Dr Nicolson, of Broadmoor Asylum, informed Mrs Scott that due to 'the lunatic's present condition' the Secretary of State could not authorise his discharge. In November, Jessie once again wrote a letter to the head of Broadmoor pleading for her husband's release. Unfortunately, on 24 April 1890, Jessie succumbed to acute pneumonia. She was only twenty-three years old when she died at No. 29 Ellison Street with her father, John, by her side.

In April 1891, Charles Palmer, MP for Jarrow, involved himself in the case when he forwarded a petition to the Home Office in favour of releasing Thomas Scott. He also requested a meeting at the House of Commons with the Private Secretary on the 23rd of the month. After the meeting was held, the Secretary of State, Henry Matthews, requested a report be complied of Thomas' current state of mind at Broadmoor. Matthews had reportedly been under fire from Queen Victoria for his inability to capture Jack the Ripper and had been in the job since 1886.

The enclosed report sent to the Secretary of State's office days later stated: 'I enclose the annual report … In this case Scott is a well-meaning industrious man sane but rather simple minded who was upset by his wife who died last year. His brother William has written to me within the past few days and expressed his willingness to give Thomas a home. Under the circumstances I think he might be allowed to go. His wife who is said to have been the chief cause of his insanity and whom he assaulted very badly is dead. She seemed to have forgiven him for she was anxious for his release while she lived. (…) Inform Sir C Palmer of course to be taken.'

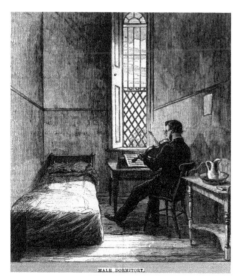

THOMAS SCOTT.—The brothers of Thomas Scott, who was recently tried for a murderous assault upon his wife, and was found to be of unsound mind, and ordered to be confined during her Majesty's pleasure, have received the following letter from him —

Broadmoor Asylum,
Crowthorne, Berkshire.

DEAR BROTHERS.—A few lines. I have got a friend to write for me, to let you all know where I am, and I hope you won't forget me now I am away, and I do hope that my wife is keeping alright, as I should like to know her address. You must ask her to write to me for I will write to her then, I cannot before. I hope her father and mother is quite well. Remember me to Mr and Mrs Johnson, hoping they are keeping well, and that I am thinking night and day about my wife, hoping she has forgiven me what I have done. In conclusion I hope you will write by return of post. Best wishes and kind love for you all. Give my wife my best and kindest love. So good-bye just now.—From your affectionate brother,

24th July, 1887. THOMAS SCOTT.

Above left: A typical patient's room at Broadmoor. (Source: *Illustrated London News*, 1867)

Above right: A copy of a letter sent from Thomas to his brothers. (Source: *The Jarrow Express*)

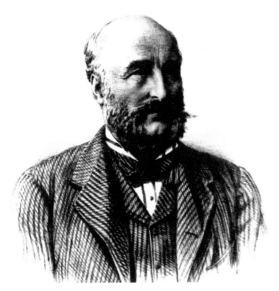 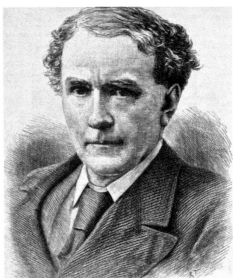

Above left: Charles Mark Palmer, MP for Jarrow. (Source: *Sporting Gazette*, 1883)

Above right: Home Secretary Henry Matthews. (Source: *Illustrated London News*, 1886)

The following letter was sent to William Scott:

Broadmoor Criminal Lunatic Asylum
Crowthorne, Workingham
3rd June 1891

Sir,

I am desired by the Medical Superintendent to inform you in reply to your letter of the 1st that he had no objection to your brother returning with you by an excursion train. Your brother's railway fare from here to Jarrow (I think about 25/-) will be allowed.

Wellington College station on the South Eastern Railway is the nearest station to the Asylum. You can book from Charing Cross or Cannon Street Stations in London.

Your obedient servant,
R. G. Hazle

Thomas was released from Broadmoor Asylum and lived with his brother William in Jarrow. The family later moved to Hebburn where Thomas enjoyed employment and didn't stray far from home. He passed away in 1903 and was buried in Hebburn Cemetery; however, Mary Ann Davidson's question had surely plagued many people's minds. Why had Thomas Scott attacked his wife so viciously and almost beaten her to death? The answers have been lost in the passage of time, but what remains clear is his head injury played a part in what violence occurred in No. 34 Ellison Street.

Above left: Another glance inside Broadmoor. (Source: *Illustrated London News*, 1867)

Above right: Jessie Scott was buried in Jarrow Cemetery. (© Ewen Windham)

Below: Hebburn Cemetery, December 2019. (© Ewen Windham)

A MARTYR TO DUTY

Joseph Scott was born on 1 March 1843 in the small Northumberland village of Hartington. The son of Richard Scott and Mary Ann Brown, he later followed in his father's footsteps and became an agricultural labourer before venturing into the world of farming livestock. Joseph wasn't content being a farmer and by 1863 he had joined the Durham Constabulary after his family had relocated to Spennymoor, County Durham. Joseph was described as handsome and charismatic. He was 6 foot 3 inches and impressed his superiors on a weekly basis with his detailed knowledge of criminal laws and his dedication to arresting those who committed crimes.

He worked hard and earned his promotions fairly. Even though his job entailed working long hours he still found time to fall in love and marry. In 1869 Joseph married Mary Coates in St Cuthbert's Church, Durham. They were blessed with a daughter in 1872 and they named her Ada. It was a busy year for Scott and he later investigated the well-known murderous case of Hayes and Slane. This crime centred around the brutal murder committed against a thirty-eight-year-old man, Joseph Waine, who had been dragged out of his home in Spennymoor and beaten to death in front of his wife.

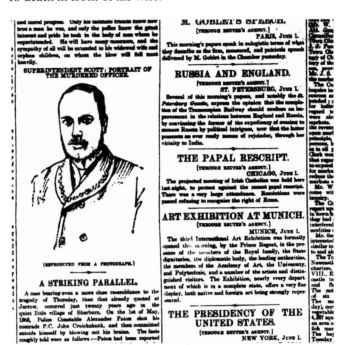

Superintendent Joseph Scott. (Source: *Newcastle Evening Chronicle*, 1888)

After the inquest had been held, the then Sergeant Scott had escorted the frightened widow safely back to her home. As Scott had been standing in the living room, he had overheard a commotion coming from the kitchen. John Mack, who lodged with the victim and was drunk, was unhappy about Scott being there. When the widow ordered Mack to hold his tongue, Mack had boldly declared, 'To hell with the bloody sergeant; he wants a bullet through him, and he'd better mind or he'll get it!' Mack was subsequently summoned to court and charged with threatening Scott's life. He was bound over to keep the peace for three months.

Due to Scott's diligent investigation into the case, the men responsible for the heinous crime of murdering Joseph Waine were later hanged at Durham Gaol. Scott was rewarded with a promotion to inspector soon afterwards. By 1881 Scott had now secured a further promotion to superintendent, though he was also widowed and raising his young daughter alone. He was given the chance to supervise his own police force in Jarrow and he took the opportunity to move to the area in August 1882. He settled into his new life in High Street and by 1883 he had married again. His new wife was Trimdon-born Annie Hardy. They had two children together: Norman, born in 1885, and Laura, born two years later.

Father of three, Superintendent Scott was as popular as ever with the men he commanded over in the local police force. He encouraged them to partake in sports and to stay away from alcohol. He even spoke of wishing to open a gym for his police constables as he thought fitness was an incredibly important aspect of the job. He was a kind and generous man who was respected across the region. Nobody expected him to come to any harm, least of all the people of Jarrow.

By mid-spring of 1887 a dark cloud had been cast across the borough. There was a police sergeant named Benjamin Wright who was slowly descending into madness. He was stationed in Hebburn and by all accounts was a man who had begun his life as a force for good in the form of a police constable. He had arrived in Jarrow on 20 December 1880 and had become secretary of the Police Constable's Christian Association. He was a primitive Methodist who was described as having a good character before it slowly began to erode. He was a married man, a father, and he was powerfully built. He couldn't look people in the eyes as he spoke to them and had begun to drink heavily. His wife, Lucy, feared living with him and when Supt Scott wanted to remove the other constable lodging with the Wright family, Lucy pleaded with him not to.

Supt Scott had been given further reports of Benjamin's strange behaviour and he thought it was necessary to intervene. Another sergeant had informed him Benjamin had taken to drinking heavily and was often seen talking to himself in court. His character changed often, much like Jekyll and Hyde. Lucy had reported that Benjamin had a sword in the house and had previously threatened to remove her head. With the evidence mounting, Supt Scott was beginning to think Benjamin was ill-suited to be a member of the police force. Suddenly, a spate of dangerous crimes stunned the inhabitants of Jarrow and Hebburn and forced Scott into reacting to the threat he believed Benjamin posed.

In May of that year three serious crimes were committed against the homes of Mr John Matheson, Mr W. Hardy and the police court in Hebburn. Matheson was the manager of Messers Hawthorn and Leslie, a shipbuilding firm situated in the town. The window of his house had been smashed by a bottle of gunpowder with a lit fuse attached. The damage was miniscule, but the intent was rather chilling. The police court and Hardy's home has also been targeted in the same manner.

When Supt Scott heard the reports, he commented only a madman would commit such crimes and he instantly ordered Benjamin Wright's home to be searched. A sergeant immediately went to the house to search it for any signs of bomb-making equipment and Benjamin erupted in anger. He screamed, he shouted, and he insulted the sergeant. He was later described as displaying 'the behaviour of a lunatic' and 'had used the most disgusting language when talking about Supt Scott'.

The behaviour of Benjamin filtered through to Scott and he had heard enough. He compiled a report, listing Benjamin's many faults. He wrote about Benjamin's forgetfulness, the way he talked to himself, the use of drink, the very strange manner he possessed, the disobedience shown, and the lack of respect displayed to his superior officers. This spelled the end of Benjamin's time in Hebburn. He was demoted to a police constable and sent back to Darlington. As he left Hebburn he destroyed several books held at the police station and it was later discovered he had been misappropriating funds. This time Benjamin's punishment was swift, and he was dismissed from the police force.

In early May 1888, another sergeant bumped into Benjamin on the streets of Darlington. Forty-two-year-old Benjamin had always been known to dress impeccably but the sergeant reported him to be shabbily dressed and smelling of drink. Benjamin reported he had a grievance against somebody and when asked what the matter was, he wouldn't answer. When questioned further he rambled incoherently and appeared to be a man who had lost sense of his surroundings.

30 May 1888 was a Wednesday and Scott spent the day at South Shields Police Court overseeing cases. As talk of a local man's illness was being discussed, Scott's response was profound, 'These east winds are playing havoc with old men.' That evening he spent time with his family. A friend visited Scott and watched him playing with three-year-old Norman. Scott was entertained by the boy's antics and spoke of his amusement at his precocious son copying every action he performed.

On Thursday 31 May, Scott was expected to join other superintendents in Durham to complete paperwork in connection to their expenses and accounts. It was a busy day for Durham Constabulary, but Supt Scott didn't leave Jarrow alone. On the early morning train, he took with him John Fannen who had been committed to gaol. As Scott left Durham railway station with his prisoner, a man with a gloomy face entered an inn on North Street, Durham. He ordered a small Irish whisky and drank it quickly. He refused to be drawn into small talk with the landlady and soon left.

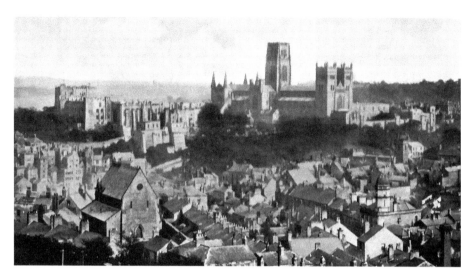

A view of Durham from the railway station. (Source: Natasha Windham)

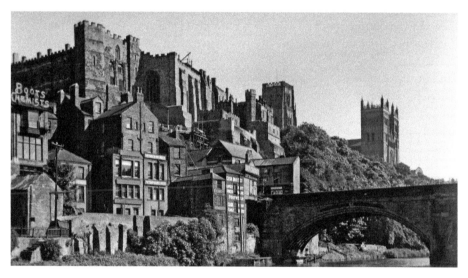

Scott's route took him across Framwellgate Bridge. (Source: George Nairn)

At 10:40 a.m., Supt Scott walked the handcuffed Fannen along North Street with a bag in his right hand and a sharp eye on his prisoner. The gloomy man was watching them pass by and he stepped out of the shadows and started to follow them. They walked across Framwellgate Bridge and on to busy Silver Street in the centre of Durham. The man was still following and Supt Scott hadn't noticed him.

As they were about to pass by the Red Lion Hotel, the gloomy man increased his pace until he was a mere 2 feet behind Supt Scott. In his hands was an Enfield rifle. Silently he pointed the rifle between Scott's shoulders and fired. Supt Scott

raised his hands, stumbled forwards and then collapsed in the cobbled road. He landed on his left side and then rolled onto his front, slumping on his face. Dozens of witnesses were horrified by the sight and the shocked prisoner, who was still handcuffed, turned to look at the gloomy man.

The man tossed the rifle onto the road and removed a six chambered German made revolver out of his coat pocket. He didn't speak and he didn't look at anybody. He turned his back, pointed the revolver to the roof of his mouth and then fired the gun. Crowds of stunned onlookers began to circle around the two men who lay dying on the ground at Silver Street. John Fannen stayed by Supt Scott's side.

Word of the heinous crime spread to Durham Police Court and dozens of police constables were soon on the scene. Percival Scott, Joseph's brother, walked onto Silver Street minutes later. He too was a superintendent and was holding a conversation with another constable. Due to the crowds of people shielding the crime scene they couldn't see who the victim of the shooting had been. Believing it was under control, they continued to walk along Silver Street.

Both bodies of the men were taken to the Red Lion Inn across the street. The gloomy man was carried to the stables where he was laid on a bale of hay. Supt Scott was left in the passageway and pronounced dead by a doctor moments later.

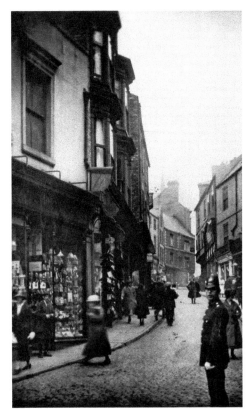

He then walked along Silver Street with his prisoner. (Source: George Nairn)

There was a wound on Scott's back, close to the spine. The bullet had entered just above the seventh rib and had caused catastrophic injuries to Supt Scott's lungs and spine. The bullet had left the body through the chest and there was a scorched hole on the front of his uniform.

The doctor left Scott and walked to the stable to check on the murderer. The man was still alive, and the doctor checked his injuries. The head of the Durham Constabulary arrived and paid his respects to Supt Scott. He then entered the stable and recognised the man who lay dying in the straw. It was Benjamin Wright. He passed away thirty minutes later, and the local police force were left in a state of shock.

Percival, meanwhile, was feeling worried. Word had leaked it was a superintendent who had been murdered in cold blood and his heart began to sink. He couldn't find his brother. An hour or so later he was informed it had been Joseph who had been killed by Wright. When asked by the press to provide a statement about his brother, he gave a passioned and loving speech about his late sibling. He was very proud of him and all he had achieved in the police force.

A telegram was sent to Jarrow Police Court about the murder of Supt Scott. The members of the court were in disbelief and silence set in across the room. Eventually one senior member of the force was sent to the Scott's home on High Street to inform his wife of the dreadful news. When asked how the Scott family were feeling, a sergeant responded that they appeared to be 'holding up well'.

The inquest into the deaths were held in Durham and they discussed the evidence in front of a deathly quiet audience. John Fannen was released by the police and they even paid his fine. In the dead of night, Benjamin's body was removed from Durham and taken to Church Merrington in Spennymoor. A coffin hadn't been provided for him and his body was draped in rags for his journey home. He was buried the very next day with his family present and 100 onlookers stealing glimpses as a murderer was buried.

In the days that followed, Benjamin's house was searched and a letter was discovered on the mantlepiece in the kitchen. He had written on blue squared paper, 'The only good this will do is to be hoped will stimulate Superintendents to always speak the truth and not resort to scientific lies when giving evidence against brother officers. It would be also infinitely better if Chief Constables would not repose as much confidence in Superintendents, for they know this and greatly depend on it.' His mother-in-law discovered a clumsily remembered Bible verse tucked scruffily in the pocket of his coat that he had worn the day he died. The verse read, 'This day shalt the Lord deliver thee unto my hands. Thus, said the Lord "He that cometh unto me, through his sins be as scarlet. I will make them as white as snow. The Lord is my Redeemer."'

As daylight broke in Jarrow on Friday morning, a hearse travelled along High Street and Superintendent Scott was home. On Sunday 3 June it was a cloudy and dull day as people arrived in their hundreds to attend the funeral. Mourners attended the final viewing of the officer's coffin. It was a polished oak,

Church Merrington, Spennymoor. (© Natasha Windham)

surrounded by floral tributes, and a simple brass plaque was attached to the front. It read: 'Joseph Scott. Died May 31st 1888, Aged 44'.

At half past one that afternoon, Scott left his home for the last time. The funeral procession was led by the bands of the 1st Durham Engineers Volunteers and the St Bede Chemical Company playing 'Dead March Saul', and even Scott's horse was part of the procession. The funeral service was held at St Paul's Church where Supt. Scott has been a member of the congregation for many years. The priest leading the ceremony had called Joseph Scott 'a martyr to duty' and the last hymn to be sung was 'Days and Moments Quickly Flying'.

Fifteen thousand people were estimated to have lined the streets to pay their respects to Scott and it took an hour for the coffin to be taken to the cemetery as the crowds were so dense. The brass bands stood at the gates playing music as his coffin was carried by the pallbearers to the south side of the cemetery. Members of St Paul's choir were also in attendance and stood by the open grave in their white robes. As Supt Scott's coffin was lowered into the ground the sun began to shine and the choir sang the hymn 'Now the labourer's task is o'er'.

The story didn't end with the death of Joseph and Benjamin. Isabella Cosgrove had witnessed the atrocity of Scott's murder and Wright's suicide.

She had been reported as being unwell in the twelve months that followed and was plagued with mental illness. By 21 June 1889, Isabella had formulated a plan of escape from her feelings of melancholy and she wrote a letter to her aunt. It read: 'Dear Aunt – I rite these few lines to you to let you know that I have a good bed and a pair of blankets at Mrs Smith's down the paper-shop yard and I am done with it. If it is sold it will get Tom a good working suit. I hope God will bless and spare your life for his sake for I have done all wrong. I hope he will turn out well. Good night, dear Tom, and be a good

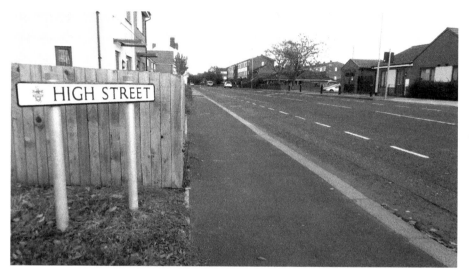

Superintendent Scott was home. High Street, Jarrow. (© Ewen Windham)

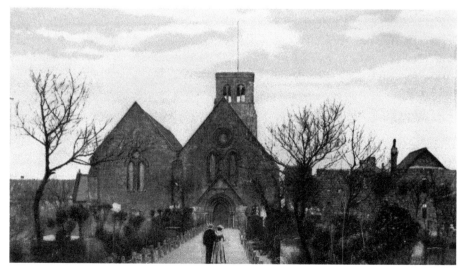

A hand-coloured postcard of St Paul's Church, Jarrow, where Scott worshipped on Sundays. (Source: Natasha Windham)

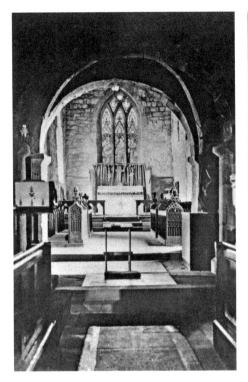

Above: Where Joseph Scott's funeral was held. (Source: Natasha Windham)

Left: The interior of St Paul's Church, Jarrow. (Source: Natasha Windham)

boy for your own sake. I will do anything rather than go to the workhouse anymore. I am just out of my mind for going. I have got what I can't get rid of. Good night.'

The next morning she left her lodgings and walked the short distance to the River Wear. Isabella stopped for a moment and told her daughter to return home. 'I will be home for dinner,' she promised the girl. Hours later a young man was passing Kepier Gardens when he spotted something in the water. Inquisitive, he made his way to the riverbank and discovered the drowned body of Isabella Cosgrove.

Benjamin's decision to commit murder had robbed a kind and caring man from the love of his family. Ada, Supt Scott's eldest daughter, was now an orphan and was raised alongside her half-siblings by her stepmother in Hartlepool. Benjamin's children, meanwhile, were sent to live with their maternal grandparents, and Isabella's children were left to rebuild their shattered lives.

It was said that two days before Benjamin Wright murdered Scott, he climbed onto Merrington church roof with his neighbours. He was reported to be carefree as he used his telescope to view the countryside around him. It is not known whether Benjamin was responsible for the spate of firebombs in Hebburn, but it's surely what fractured the belief that the ordinary policeman was a trustworthy face in a sea of danger.

Above left: Superintendent Scott's headstone in Jarrow Cemetery. (© Ewen Windham)

Above right: The final resting place of Joseph Scott. (© Ewen Windham)

Church Merrington, Spennymoor, where Benjamin Wright is buried. (© Ewen Windham)

SHE NEVER TOLD ME HER TROUBLES

Hannah Proud lived a troubled and turbulent life marked with heartbreak and misfortune. She was born in Jarrow in 1878 to parents Thomas Proud and Elizabeth Grieves. Irishman Thomas was a brooding man who worked as a blacksmith striker. Tragedy often trailed the Prouds and would ultimately tear them apart in the most shocking and violent of ways.

Death seemed to haunt the Proud family wherever they called home and it claimed its first victim in 1876. The eldest Proud child, ten-year-old Thomas, died of natural causes and the family later named a newborn son in his honour. In 1886, another Proud child, eleven-year-old Jane Ann, passed away. An inquest into her death was held at the Queen's Hotel, Western Road, by Coroner Graham. Elizabeth attended the inquest to state her daughter had passed away on 26 September that year. She explained her husband had been unemployed for two years, having been ill for eight months of them, and they had only sought parish relief once in that time period. Dr Jennings, who had been called to the home of the Proud family after Jane Ann had passed away, didn't know the cause of death. After much discussion, the coroner and jury carefully suggested the death could have been connected to malnutrition because the Proud family were in abject poverty. A verdict was later returned to state Jane Ann had died of natural causes, probably heart disease.

Three years later, in 1889, tragedy once again came knocking at the door of No. 89 Western Road. The Proud family lived in the ground floor flat with their youngest four children, but unhappiness plagued the marriage of Thomas and Elizabeth. Unpleasantness had started to stifle the relationship and their children were seeing the cracks starting to appear. Fifty-six-year-old Thomas had been drinking all race week and had argued with their lodgers about a joint sweepstake. He had won 12s 8d but refused to share it with them. Elizabeth had told him he must, but he responded furiously and ordered, 'shut your mouth!' On Wednesday 3 July he had returned home at five o'clock for his dinner when an argument had erupted over him always getting drunk and losing his employment. He picked up a knife and threatened to stab his wife. 'I will put that knife through you if you don't get out of this,' he warned angrily.

Elizabeth picked up a brush to defend herself and then had fled outside to the backyard. Thomas had followed with the knife, but their son George, aged fifteen, stood up to his father and took the weapon away. Thomas was furious and threatened Elizabeth once more. 'There'll be murder the night when I come home.' He left for work again and when he returned later that night, he was quiet and wouldn't talk to his wife or family.

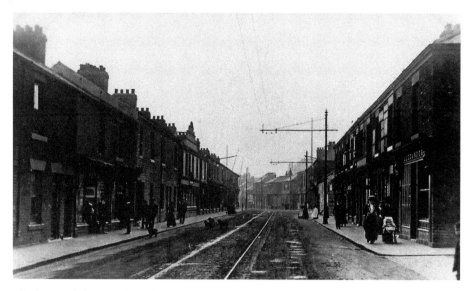

The home of the Proud family – Western Road, Jarrow. (Source: George Nairn)

Thomas didn't earn any wages on Thursday 4th but spent the entire day away from the family home. He told his son George he was 'bad with the gas' from the works. At quarter to nine that evening he returned home, wouldn't talk to anybody and went to bed.

In her own words, twelve-year-old Hannah Proud described what happened at quarter to two that morning.

I live at 89 Western Road. My mother's name was Elizabeth, and she was 47 years of age. I was in the house on Thursday night. There are only two rooms in the house, which is on the ground floor. My mother went to bed about five minutes before me. My bed was alongside the bed occupied by my father and mother. The two lodgers were in bed, and also two brothers George and Thomas, and one sister, Elizabeth. The little girl slept with me, and the brothers and lodgers in front. The lodgers are Charles Whitworth and Thomas Phillips.

After I went to bed the first thing I remember was my mother getting out of bed and coming to me and getting hold of me by the hand. She said her throat was cut. Her exact words were, 'He's cut my throat'. The lamp was lit, and I could see her. She was bleeding from the throat. She asked me to tie a towel round her throat which she held in her hand. I tied it round tight and went and called the lodger. I went into the room first and she followed me. My father was then in bed. He was awake and could hear what was said. When my mother spoke to me, I looked at my father and I then saw his throat was cut. My father did not get out of bed. I shouted to Charles and asked him to get up. I said, 'Charlie get up, my mother's throat is cut.' My mother followed me and was standing at the door when I said this.

Charlie and my brothers got up and George got on his things and went for the doctor, and Charlie went for the police. My mother went back to bed. The other lodger went to the door. My little brother and sister remained in bed. My mother went back and lay down on the bed in the kitchen where my father was. Mrs Downes, a neighbour, came into the house first, before the police or doctor. A policeman came, and then Drs Inglis and Norman. My father had not been drinking that I heard of and he was sober the night before. My mother and he had words last week. That was last Saturday. I went out for a policeman then because my mother sent me. I did not hear what he said. I never heard my father threaten my mother.

The doctors and police carried Mrs Proud to a bed in the front room and tried in vain to save her life. Despite their best efforts, her condition worsened and she passed away at 5:15 a.m. on Friday 5 July. Her official cause of death was 'exhaustion through loss of blood and nervous shock'. Her husband, who lay bleeding, calmly asked for a glass of water as he was examined by the doctors. The vicious self-inflicted wound across his throat was carefully stitched but at 10:30 that morning the stitches burst during a coughing fit and he died thirty minutes later. As news of the deaths broke across Jarrow, swathes of curious onlookers gathered outside the house.

On Saturday 12 July, an inquest was held into the violent deaths of Thomas and Elizabeth. The jury viewed the bodies of the deceased and then heard the evidence of the witnesses, including the Proud children and their lodgers. Towards the end of the hearing, the Foreman had said, 'There can be no doubt that the deed had been done whilst the man was in a state of temporary insanity.'

'I do not understand what temporary insanity is,' a juryman replied. 'Perhaps the man was not in his right senses. I can readily understand a man, going through what this man has gone through during the past week, being in a state of temporary insanity, but this man had told his wife beforehand that he would commit the deed. I think he was in his right state of mind, and that the deed was premeditated.'

The coroner agreed with the sentiments of the juryman and when discussing Thomas' murderous act had said there was, 'Method in this man's madness,' but further explained they needed to be 'charitable' in the way they viewed this case. The jury returned verdicts of 'wilful murder' in the death of Elizabeth Proud. In response to Thomas' death, they stated, 'That the deceased man committed suicide by cutting his own throat, at the time being temporarily insane.'

The following day, a joint funeral was held for Elizabeth and her murderer. Large crowds began to gather at Western Road, close to Palmer's Steelworks, long before the event began. At three o'clock the coffins were carried from No. 89 Western Road and placed inside the hearses. Fifteen minutes later, thousands of spectators lined the roads of Ellison Street, Grange Road and Monkton Road. Four hundred and fifty people followed the solemn procession to

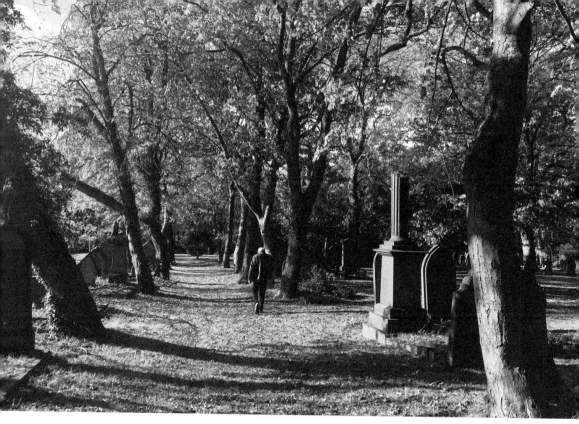

Jarrow Cemetery, the burial place of Thomas and Elizabeth Proud. (© Natasha Windham)

Jarrow Cemetery where the two plain black coffins, with wreaths on top, were buried in the same grave.

On 8 August, Hannah and her two younger siblings were dressed in mourning clothes when they were escorted to the police court by Revd J. Bee of Christ Church, Jarrow Grange. Bee asked the magistrates to please sign paperwork to allow the youngest of the Proud children to be admitted to an orphanage. Revd Bee promised he would see the children were well taken care of and subsequently found a home for three of them: Hannah was sent to the gloomy Abbot Memorial School in Gateshead, nine-year-old Thomas was admitted to an industrial school in South Shields, and six-year-old Elizabeth was taken to Northumberland Village Home for Girls in Whitley Bay.

Hannah was taught needlework, the importance of being a housewife and instructed on how to clean a home. She would also have been tasked, alongside other girls, with cleaning the boys' clothes while being trained to be the perfect maid. Several years later, Hannah left the school and went straight into service as a servant in Middlesbrough. Eventually, she left her employment and returned to the north-east of England, settling in Sunderland. She never married, though her brother Thomas wasn't certain about her living arrangements. In March 1910, Hannah had been living in the downstairs room of No. 31 Tatham Street for three months. It was close to both the docks and the seamen's mission. Hannah was described as 'rather passionate in temperament and despondent at times'.

Abbott Memorial School, Gateshead. (Source: Natasha Windham)

She chose to live under the pseudonym of Nancy Ward, though many knew her real identity. According to an upstairs neighbour, Hannah's only visitors were men who frequently visited at night.

Despite the circumstances she found herself in, Hannah still enjoyed life. She had also fallen in love with one of her frequent callers. His name was Carl Rudebeck. He was a forty-four-year-old married Swedish captain of coal steamer *St Paul*. On the night of Wednesday 30 March, Hannah and Carl returned to her home on Tatham Street at 23:30 p.m. An upstairs neighbour, Rachel Davis, heard what she described as 'excited talk'. All was quiet until she heard the man leave at 1 a.m. Rachel then heard a bottle smashing and then a thud. A man's voice then called from below. 'Missus, will you come down? Mrs Ward has shot herself!' Rachel was too frightened to go downstairs, but her husband dressed and hurried to offer his assistance.

The voice belonged to Captain Rudebeck. He stepped outside the house and blew a whistle. The sound carried to the next street where PC John Crawford was patrolling. The police constable went to the scene and entered the downstairs room with Rudebeck and Rachel's husband. They found Hannah, dressed in her nightdress and stockings, lying on the bed. She was on her left side with a pocketbook clasped in her hands. Beside her was a Belgian magazine pistol that had been a gift from Rudebeck six months previously. A bullet wound could be seen on Hannah's left breast. A doctor was sent for, but PC Crawford could find no signs of life from Hannah.

Above: Hannah lived on Tatham Street, Sunderland. (© Natasha Windham)

Below: Tatham Street, Sunderland, 2019. (© Natasha Windham)

He took the pocketbook from her and looked through the pages. In Hannah's handwriting he found a short note to her brother Thomas. It read, 'All I have I leave to you. Ask Billy Hall how I stand, and he will give you help to pay just debts.' There was another entry stating there was £12 10s in the house and £4 in the Cooperative Society. There were also diamond rings Thomas could sell if he wished, and a small mention of Carl Rudebeck and £50.

As police surgeon Dr Hickey arrived, he examined Hannah and discovered the wound under her chemise was gunpowder stained. He said the evidence showed the pistol had been held close to the body when fired and determined it was most likely suicide. Further evidence was heard at the inquest on Friday 1 April in the Primitive Methodist schoolrooms on Tatham Street. Hannah's brother Thomas, now occupied as a coal miner, spoke of his surprise his sister had taken her own life, though admitted the last time he had seen her she had told him that she 'did not think she would last long' and 'often complained about her heart'. He knew how his sister made a living but had never seen her depressed or despondent.

Maria Jones, Hannah's friend and charwoman, had known her for almost eight years. She described Hannah as a passionate woman who sometimes threatened to take her own life.

The Seamen's Mission, Tatham Street, Sunderland. (© Natasha Windham)

'Do you think she was a likely woman to commit suicide?' the coroner asked her.

'I do, because she always said she would take her own life,' Maria responded.

The coroner continued his questioning. 'Why did she threaten to do that?'

'I don't know; she never told me her troubles,' Maria admitted, possibly wishing she had known more about Hannah's woes.

Hannah's room had been undisturbed, there was no sign of a struggle, and a further search of the room found several pawn tickets, more jewellery and £11 8s 4d in a drawer. Captain Rudebeck attended the inquest, though didn't take the stand as the coroner said the noticeably distraught captain couldn't add any further information to the case. The jury returned a verdict of 'The deceased committed suicide by shooting herself whilst temporarily insane.'

Carl Rudebeck now had the weight of the world on his shoulders. His relationship with Hannah had been heavily hinted at in newspaper print across the country. He was a master mariner, a Freemason at the Thornhill Lodge in Sunderland, and, most importantly, a father of one. But still, he mourned for Hannah. In the following days Rudebeck and his staff were kept in Sunderland longer than normal due to an engine problem with their coal steamer.

Roker, Sunderland, 1909. (Source: Natasha Windham)

The seafront at Roker, Sunderland. (Source: Natasha Windham)

A hand-tinted postcard of Roker Beach, Sunderland. (Source: Natasha Windham)

The captain's friends were worried about him and his depressed state of mind. On 10 April, he took a Sunday morning stroll along Roker beach with a friend. Suddenly, he ran toward the sea. As his friend followed, Rudebeck rushed against the tide and was almost swept out until his colleague wrestled with him and brought him back to the beach. Captain Rudebeck left Sunderland the following morning on his steamer, *St Paul*. Their destination was Rudebeck's home – Gothenburg, Sweden.

The officers and crew kept watch over him, noting his usual cheerfulness had been replaced by a depressed look in his eyes. It was a two-day voyage and as the steamer had almost reached Gothenburg a steward leaving the cabin saw Rudebeck jump overboard. The crew sprang into action and a boat was lowered into the sea in a bid to save their captain's life. Unfortunately, a short time later the lifeless body of Carl Rudebeck was recovered. Several days later, the steamer returned to Sunderland where it docked for coal. The docks were awash with people expressing their sympathies for the loss of Captain Rudebeck. He had been known as a kind and cheerful man who often employed the poor to work odd jobs on the ship when at Sunderland.

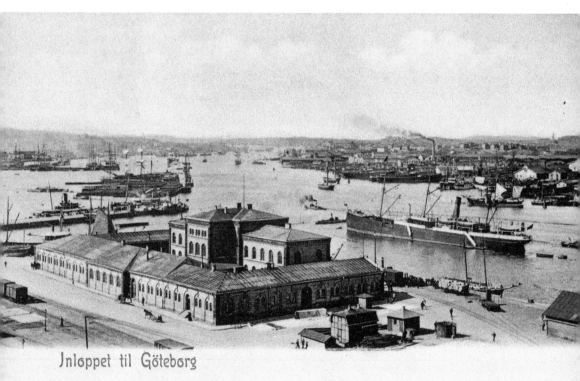

Jnloppet til Göteborg

Import: Joh. Ol. Andreens Konstförlag, Göteborg

Captain Rudebeck's destination, Gothenburg, Sweden. (Source: Natasha Windham)

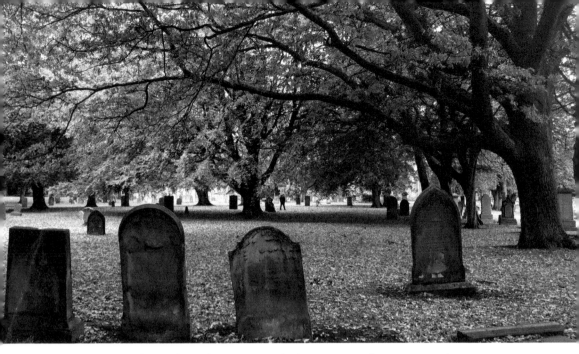

Above: Hannah was buried in an unmarked grave in Bishopwearmouth Cemetery. (© Natasha Windham)

Below: Bishopwearmouth Cemetery, Sunderland, October 2019. (© Natasha Windham)

Twenty-one years earlier, twelve-year-old Hannah had been desperately trying to wrap a towel round her mother's throat. One of the lodgers had heard the girl's panicked scream of, 'Oh Mother, don't do that!' as she frantically begged the critically injured woman not to pull the towel away. Hannah had been terrified of losing her mother. The loss she must have felt would have been immeasurable when she was also separated from her siblings and taken away from the only home she had ever known. The mental anguish of children was often overlooked when violence erupted in the home and Hannah was ultimately a victim of her past. Forever stained with her mother's blood, she must have been plagued by horrific nightmares of that fateful night. Hannah's spirit was broken more than once and, in the end, both she and Captain Rudebeck succumbed to the darkness and torment that had caused her to reach for the gun.

REVENGE IS SWEET

John 'Jack' Swinbank was suspicious, possessive and wrathful. He was a coal miner by trade and had met his future wife, Mary 'Polly' Stoker, in Jarrow in 1891. Mary was raising an illegitimate son from a previous relationship and working as a maid on Albert Road. They married on 2 January 1892 and lived in the home of Mary's parents beside St Paul's Church and directly opposite the old River Don bridge.

Mary thought she had married the perfect man, but within days John had become sullen and refused to allow her to meet any friends alone. He started to assert his own rules in the home and Mary's mother, Eleanor, grew concerned. Over the course of eight weeks his anger grew and culminated in him becoming violent. Unfortunately, the cruelty was directed solely at his twenty-two-year-old wife. When John started to strike her, his parents-in-law were appalled, and they ordered him to leave their home on 5 March. Revenge was now the only thought dominating the mind of John Swinbank.

J. D. Rose's photograph of the coal miners' cottages close to St Paul's Church, Jarrow. (Source: Kevin Blair, Phyllis Claxton and James Rose)

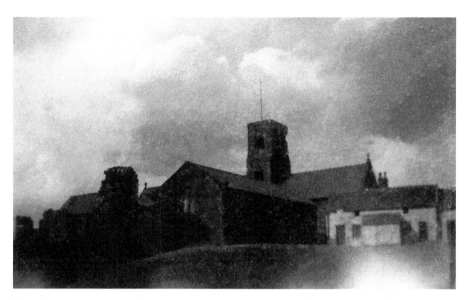

The photo is in poor condition yet provides us the perfect glimpse of St Paul's Church and monastery, beside the white cottages. The photographer is unknown. (Source: Natasha Windham)

He rented a room in lodgings at Boldon Colliery. Those he worked with commented he often spoke of his mother-in-law and stated he would 'end it one of these days'. He told his friends he felt 'very miserable' because he no longer lived with his wife. In the subsequent weeks he visited his wife often. Mary was now suffering from the symptoms of flu and had been confined to bed for two weeks, but John had accused her of visiting other men and planning to remarry.

On 18 March, during a miner's strike, John travelled to Jarrow and went to the home of a Mrs Palmer. His behaviour was described as normal and he showed no signs of anger or distress. Ten minutes later he left and walked to his wife's family home, close to the River Don.

As he entered the house, he greeted Mrs Stoker. 'It's a fine day.'

'Yes,' Mrs Stoker replied as she was washing dishes in the kitchen.

'Is Polly any better?' he asked his mother-in-law.

'She is. She is asleep; do not wake her.'

Swinbank ignored the warning and went to speak to his wife in one of the bedrooms. 'Is your mother preventing you from living with me, Polly?' he demanded to know.

Mary gazed at her husband. 'No Jack, but on account of your bad behaviour I can't live with you,' she had replied honestly.

He stood up, left the room and returned to the kitchen. As Mrs Stoker continued with her daily chores, he knew they were alone. His father-in-law and Mary's brother were both employed at Boldon Colliery and had been called into work.

Boldon Colliery, where Mary's father, brother and husband worked. (Source: Kevin Blair)

Out of the corner of her eye Mrs Stoker noticed John remove something from his pocket. There was a 'bang!' and she felt pain radiating across her right shoulder. She turned to glance at him and shock overcame her. He was holding a revolver. She ran from the house screaming 'Murder! Police!'

Mary, having heard the gunshot, left her bed and ran towards the front door. She was in a weak state physically and her husband easily caught up with her as she rushed in the direction of her next-door neighbour's house.

Mrs Stoker reached the safety of Mr McGuiness' home first, but as Mary attempted to enter the house another shot rang out in the peaceful neighbourhood. Mrs Stoker shouted 'My daughter has been shot!' as she ran into her neighbour's arms.

A shocked Mr McGuiness tried to comfort the woman and then peered outside and saw Mary lying on the doorstep. He watched Swinbank walk calmly toward Mary and shoot her a second time. The gun was then pointed towards Mr McGuiness. 'I'll shoot you too,' John warned angrily. The worried Mr McGuiness quickly closed the door and left through the backyard to fetch the police.

Hearing the commotion in the usually quiet neighbourhood, people left their homes. John started to pace frantically, waving the revolver in the air and threatening to shoot the spectators if they dared approach him. He paused beside the Don Bridge and called out in a sing-song voice, 'Revenge is sweet! Revenge is sweet!' He then pointed the revolver to his mouth and pulled the trigger.

Above: Outside the miners' cottages in Jarrow. J. D. Rose's photograph, *c.* 1898. (Source: Kevin Blair, Phyllis Claxton and James Rose)

Below: 'Revenge is sweet' on the old River Don bridge. (© Natasha Windham)

At 3:20 p.m. there was a thud as John Swinbank's body landed on the cobbled ground at the foot of the bridge. The residents of the street cautiously approached him and discovered he was very much dead. Sergeant Thomas arrived, shortly followed by Superintendent Fleming, who picked up the revolver and checked to see if it was still loaded. It was a five-chambered weapon and still had one ball in the barrel. They also found a box of forty-five cartridges in Swinbank's coat pocket.

Dr Bradley soon arrived on his bicycle and pronounced John Swinbank deceased. The body was moved to nearby stables owned by Mr McKangey and then taken to the mortuary. The doctor then went to Mary's aid. She had been shot once through the chin and the bullet had passed through her mouth. The second bullet had travelled through the lobe of her right ear and lodged in the ground. Neighbours, Mrs Millar and another woman, helped carry Mary into her parents' home as a search was made for her mother. Mrs Stoker was discovered sitting on the ground behind McGuiness' house. She was in a state of shock but luckily her shoulder wound was only superficial. Mrs Millar, meanwhile, cleaned the blood from Mary's face and tried to soothe the injured woman's worries.

The following day an inquest into the death of Swinbank was opened at Jarrow Police Court by deputy coroner Mr Shepherd. The witnesses gave evidence and it was stated that Mary was still in a serious condition and unlikely to survive. Before the inquest was adjourned, a key piece of evidence was read out in court. A handwritten letter had been found in the pocket of Swinbank.

friday, 18th, 1892

Dear frinds, i wish you all good By, and I hope you will not let my farther now about This rish act that I have don. But i could not helpp it, and I don't want to fish anyone in it. But my slf i have been Driven To it Through my Wife mother

The cottages beside the church were demolished many years ago. (© Natasha Windham)

and farther and all the family I couldand Stand it for the lies That has been said About me and i have Ben away 3 weaks from. Tha put me out and i Went away and She said She would marry hor Old Lad. And she fished him to the house and Was thir when i cam from work i have said All i will say about it. Fair well to all my frinds and 1st everythink be left to my farther and brother. And i wish all that nos me will com and see the last of me, Brothers and sisters x x x x friends i must go and Bob, take my pistle and all. So good by, it is not my wife fault, it is her mother fault x x x x This is love.

In a feverish desire to spread the news of Swinbank's murderous act, newspapers far and wide printed the story of an estranged husband's controlling nature descending into the abyss of violence. *The Jarrow Express,* however, almost depicted him as a forlorn figure who couldn't be held wholly responsible for his heinous actions. The editor wrote, 'Whatever minor impulses Swinbank was influenced by, there were at least two motives which led to the commission of the awful deeds. These were jealousy and some measure of interference by his mother-in-law.'

Contrary to what Swinbank thought, he wasn't acting out of love, and revenge was indeed sweet for one person. Mary Stoker survived her husband's premeditated attack and remarried in 1893. She was able to live with a sweet and stable man in the years that followed Swinbank's death and she sadly passed away of natural causes in 1933.

Swinbank's friends at Boldon Colliery were shocked by the news of his crimes. (© Ewen Windham)

Above: The old River Don bridge is now a peaceful place. (© Natasha Windham)

Below: John Swinbank was buried in Jarrow Cemetery. (© Natasha Windham)

ARE YOU TIRED OF ALL YOUR BADNESS?

Michael McWilliams Bradley, more commonly known as Dr Bradley, was born in Ireland in 1846. He arrived in Jarrow in 1872 and later became the police surgeon. He was a justice of the peace and magistrate on the police court for thirty years. A well-respected man, he married Elizabeth Fenwick, a house agent's daughter, in 1884. He was a member of St Bede's Church and lived in Avondale House on High Street. He was a great believer in taking care of the poor and often fell afoul of what he considered overzealous bureaucracy. After being summoned to court for an ashpit violation in one of his tenant's houses and butting heads with the sanitary inspector, he said, 'The desire of these men is to get as much money out of me as possible.'

Dr Bradley, like his dear friend James Dudfield Rose, wished to help the poor and was often treating dozens of patients daily. As he stood in Rose's druggist store on the corner of Ormonde Street in May 1894, he heard a commotion outside. A little girl had run into the road and been knocked down by a horse and cart. She was rushed into the chemist shop where Dr Bradley examined the crying girl. She had suffered injuries when the horse had trodden on her, but she was hastily treated and survived her ordeal.

St Bede's Catholic Church, Jarrow. (© Natasha Windham)

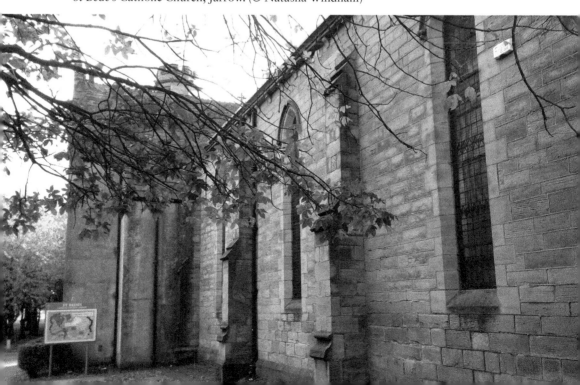

J. D. Rose's photo of a shop in Jarrow. (Source: Phyllis Claxton and James Rose)

Money is the root of this story, but unlike Dr Bradley, who had areas of great interest outside of it, the main antagonist of this tale, Daniel Campbell, held his bank balance above all else. Daniel Campbell was born in 1842. He was a man of many grudges, despised those who crossed him and often sought revenge in the most threatening of ways. In his lifetime he would terrorise those he accused of being disloyal to him, including his own wife and daughter. His story is plagued by policemen investigating his many reigns of terror and culminates in a violent rampage with Dr Bradley's wife in his murderous sight.

The story began in February 1871 when Daniel married Mary Campbell. They had one daughter, Mary Ann, who was born in 1872, but their marriage didn't last. Their fractured relationship limped on for twelve further months but eventually, in November 1873, they parted due to Daniel's unreasonable and aggressive behaviour.

In 1887, Daniel was injured in his workplace, Messers Tennant and Partners, a chemical manufacturer, where he suffered a crushed chest. In line with the Employment Liability Act, he was given half pay and supplied with medical assistance until he had fully recovered. Daniel subsequently sued them but at the very last moment changed his mind and dropped the case. Messers Tennant were entitled to costs and Daniel was informed he owed them money.

He was furious, made threats, used coarse language and was in a rage when visited by Police Inspector Snowdon. His threats escalated in their violent overtones and he threatened to 'blow his brains out'. Mr Stewart, Daniel's employer, feared for his life and approached Campbell through Revd Dr Toner, Roman Catholic priest of Hebburn. During the meeting Daniel asked for money. Mr Stewart authorised a payment of £40 to be given to Daniel in front of the priest.

Nine months later, Daniel accused Mr Stewart of stealing £40 from him. He claimed the payment should have been £80, but half of it was missing. Due to the worsening threats, Daniel was sent to prison but once released Mr Stewart found him a job at Jarrow's shipyard. Daniel, however, continued his campaign of harassment. He sent a hostile letter to Mr Stewart on 29 September. He was again arrested, and a loaded revolver was found in his home. Daniel pleaded guilty to the offence of sending a threatening letter for the purpose of extorting money.

During the sentencing, the judge stated, 'It must be understood that the Court will never allow people to take this sort of remedy into their own hands by threatening their fellow man. It is a hideous offence and one that must be stopped.' Daniel was imprisoned in Durham Gaol with ten months hard labour.

In August 1890 Daniel was once again charged with intimidating Mr Stewart by visiting the street he lived on in Whitely Bay. He refused to be bound over to keep the peace and requested to be sent to prison instead. By March 1891, Daniel was living at No. 250 High Street, Jarrow, but still found himself on the wrong side of the law. He was summoned to South Shields Police Court to answer charges of threatening to murder his estranged wife, Mary. She had been walking to the Catholic chapel in Tyne Dock with their daughter when Daniel had approached them. 'Good morning,' he had said, before following them. 'Are you tired of all your badness?' he asked her as he stood in front of his wife and blocked her path.

Mary replied reminding him they hadn't spoken in quite some time and then asked him if he would please allow her to pass. He refused and drew a revolver from his breast pocket as he issued a menacing threat. 'This is how it will end,' he replied darkly as he pointed the weapon at his wife.

His daughter screamed in fright and a Mr Farrell, who was standing nearby, rushed over and stood between Mr and Mrs Campbell. A grumbling Daniel had walked away with the weapon still in his hand. Mr Farrell asked Mary if he should follow and disarm Daniel. Mary was worried Mr Farrell would be hurt so she advised him to let her husband leave.

At South Shields Police Court Mary explained to the justices of the peace that she had seen Daniel the previous week at Jarrow Slake. They had passed each other on the footpath and she had been frightened of his presence. She also stated he had visited her home several times a week and told her he had every right to be there and wouldn't be removed. She had never received a penny from him in the eighteen years they had been separated and constantly lived in fear of his behaviour. After the last of the evidence was heard, Daniel was bound over £50

Stanley Street neighboured Princess Street. (© Ewen Windham)

to keep the peace and charged a further £50 in sureties. If he defaulted on the payments, he would be sent to prison for three months.

In 1893, Daniel lived at No. 17 Princess Street, Jarrow, and was imprisoned for three months. He had been found guilty of common assault after attacking his estranged wife. Mary was able to provide for herself and her daughter because of her parents' newsagents business she had inherited. Since the revolver incident at Tyne Dock, Mrs Campbell and her daughter had been under police protection. On 27 May 1893, Daniel had arrived at the shop in East Jarrow and entered through the front door of the newsagents. He was carrying a piece of iron that he used to fasten the door shut. He then walked to the back room where mother and daughter were. The terrified women saw the glint of a firearm as he smashed the glass of the door that led to the living room. They screamed as they ran through the backyard and out into the safety of the street.

Dr Bradley attended to Mrs Campbell the following day. He stated she was still in deep terror and had been having heart palpitations. She was living with a heart condition and had almost been scared to death by Daniel's wrathfulness. She subsequently took out a protection order from the court. Daniel had been seen with a doubled-barrelled shotgun in the area close to the shop by other witnesses and a warrant for his arrest was issued. He fled to Scotland for several weeks, but on his return, he was arrested and remanded in court to be committed to trial. Three months later he stood before the judge in Durham as he was sentenced.

Mary Campbell passed away in January 1906. She had outlived her own daughter and had been raising her two grandchildren, Mary and Francis Keenan, alone. Dr Bradley and his wife were godparents to the Keenan children,

Many funerals were held in Jarrow Cemetery. (© Natasha Windham)

but Daniel had no contact with them. In late May 1906 Dr Bradley passed away at his second residence in Ireland. He had been sent there by his doctor in the hopes that spending time in the countryside would lessen his suffering and help alleviate his symptoms. It wasn't to be, and upon his death his body was returned to Jarrow where a mass was held at St Bede's Church. His polished oak coffin was buried at Jarrow Cemetery in the presence of a large group of mourners that included James Dudfield Rose.

Mrs Bradley later moved to Balgownie House on Bede Burn Road but continued to support the Keenan children. Mary Campbell's property was heavily mortgaged, and she had been in debt when she had died. The furniture and stock were sold, and the money given to the creditors, but Daniel thought he was entitled to the belongings. He was furious when he discovered he wouldn't inherit a single penny from his estranged wife, and he blamed Mrs Bradley.

Terror would soon storm the streets of Bede Burn Road as Daniel once again intimidated and terrified another vulnerable victim. He started sending the widowed Mrs Bradley threatening letters accusing her of stealing his property. Worried by the growing threat he possessed, Mrs Bradley spoke to her trusted solicitor John Alexander Livingston and asked for help in resolving the matter.

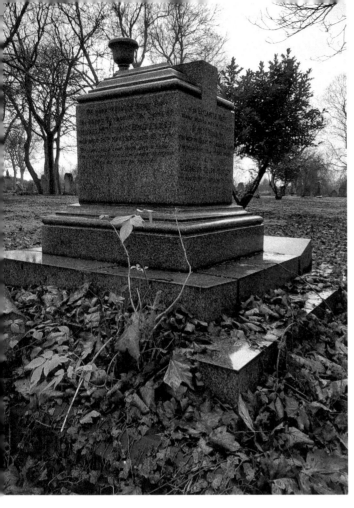

Left: Dr Michael McWilliams Bradley's grave at Jarrow Cemetery. (© Ewen Windham)

Below: Bede Burn Road, Jarrow. (Source: George Nairn)

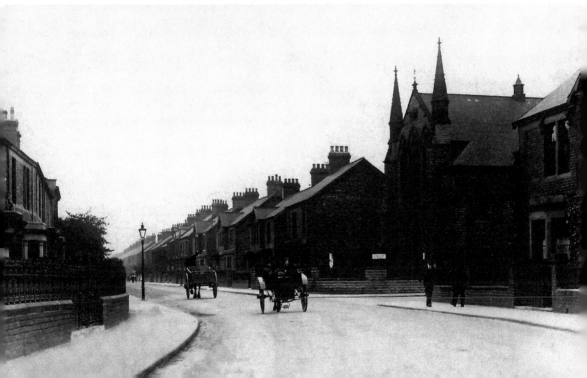

Livingston met with Daniel and explained the situation over several meetings. Still, the letters continued to arrive.

On 6 September 1907, Mr Livingston enclosed the following in a letter to Daniel: 'Mrs Bradley wishes you to understand that she has nothing in her possession belonging to your wife's estate and has asked me to arrange an interview with you.'

Both parties continued to negotiate a meeting. Meanwhile, Daniel took out a gun licence at Sunderland Post Office. The following day he travelled to Newcastle upon Tyne and bought a revolver in Pape's gun shop at No. 29 Collingwood Street. He continued to converse with Mr Livingston, who sent a telegram stating, 'call here with your solicitor tomorrow, Tuesday morning, at 10:30, and will give you interview with our client'.

The following day Daniel met Mr Livingston on Bede Burn Road. When asked where his solicitor was, he said, 'He has gone for a walk in the park.' Livingston led Daniel into Balgownie House and entered the dining room where Mrs Bradley was waiting.

They started to discuss the matter at hand with Daniel repeating the same sentence throughout the meeting: 'You have got my money and I'm going to have it,' he told Mrs Bradley.

As Mr Livingston told Daniel it was needless to argue, Daniel produced a loaded revolver. 'So, it has come to this,' he said threateningly as he pointed the gun at Mrs Bradley. She screamed and ran from the room, leaving Mr Livingston to face the threat alone.

Daniel walked across the hearth rug with the firearm now pointed in Mr Livingston's direction. 'Put it down you will get yourself into trouble, and won't frighten me with that,' Livingston said, standing up.

Stepping closer to Mr Livingston, Daniel held the gun steady. 'Are you going to pay the money?' he asked as he suddenly fired the weapon. The bullet grazed Livingston's chin and Campbell instantly fired again. The second bullet pierced a painting hanging on a wall.

Mr Livingston escaped the room and, with the assistance of a maid named Miss Quigley, outran Campbell, who was following behind. As Livingston reached the front garden of Balgownie House he began to worry about the safety of the people he had left behind. He bravely returned to the house in an act of absolute heroism. As he reached the hall door, Campbell once again fired at him. The bullet lodged in Livingston's left arm close to his elbow, but still he fought on. With the incredibly brave Miss Quigley's help they held onto Campbell and began to push him through the open front door.

A struggle ensued between Mr Livingston and Daniel in the front garden. After some time had passed and the men began to tire, Daniel fired another shot and both men fell. In a brave effort to thwart Daniel's revenge, Mr Livingston managed to push him onto the rockery. Stunned for a moment, Daniel dropped the weapon. Livingston picked up the gun but was worried as

The front garden of Balgownie House in the present day. (© Ewen Windham)

Daniel climbed to his feet and started to issue menacing threats again. Exhausted and in pain, Livingston staggered towards the road and called for help.

Market gardener Fred Atkinson was passing by the house on his horse and cart as he heard Mr Livingston's cries. He stopped and went to his assistance. David Hill, an insurance agent, also went to help. As they approached the scene at Balgownie House, they were horrified to see Daniel with a knife. They held onto him but as they released him for a moment, Daniel held the knife to his own throat and did the unthinkable. George Hornby, a local plasterer, attempted to intervene but during the scuffle he was stabbed in the leg. The bloodied would-be murderer collapsed to the ground, and Dr Nicoll was sent for.

The police arrived on the scene as large crowds of people started to gather in the street. Daniel's throat was bandaged, and he was taken to Palmer Memorial Hospital on the back of a fruiterer's cart with Sergeant Binns, Sergeant Benzies, and PCs Foreman, Carrick and Fowler guarding him. Luckily, Mr Livingston's injuries weren't serious, but he was reported to be in a great state of shock. He was taken to his own home at Dunedin House, Albert Road, where he was ordered to rest in bed. He had the bullet removed from his arm the following day.

Daniel, meanwhile, was in a pitiful state in hospital. His self-inflicted wound was incredibly serious and such force had been used it had severed his windpipe. He wished to die, and the police officers kept close watch of him throughout the day and night. Against all odds, Daniel survived and was soon fit to stand trial.

Bede Burn Road, Jarrow. (Source: George Nairn)

When arrested and charged, Daniel struggled to speak, but had told Sergeant Binns, 'Very well. There is no doubt the man went and robbed me and left me penniless. He actually sold my clothing in South Shields, pocketed my money and laughed at me passing.'

On Monday 23 December, Daniel appeared in Jarrow Police Court. He was charged with attempted murder and trying to commit suicide. Mr Dingle, who represented Daniel, questioned Mr Livingston. 'Do you think Campbell went there intending to shoot you?' he asked.

Mr Livingston considered his answer for a moment. 'I cannot say,' he replied steadily. 'I think he went to shoot someone.'

After the last evidence had been heard, Daniel was committed to trial at Durham Assizes. In February 1908, he was sentenced to twelve months hard labour in a remarkably short sentence after causing such terror.

Daniel Campbell was a man with money on his mind. As he had struggled with Mr Livingston, he could be heard violently seething: 'They are highway robbers and have robbed me of every penny!' He deliberately and repeatedly rained terror down upon those he believed had wronged him. The protection order Mary Campbell had taken out against Daniel guaranteed he would never gain control of her property, but he was still intent on taking what he believed was his. He was a seemingly selfish man who had been corrupted by greed, and ultimately died penniless and alone.

HIS DANCING IS REALLY CLEVER

Robert Campbell was born at No. 9 Lord Street, Jarrow, on 28 August 1873. He was the son of ship riveter Hugh Campbell and Margaret Morrison. Robert was a fearless boy who often played in the bustling streets, weaving through the busy traffic without fear of harming himself. On Thursday 8 November 1887, four-year-old Robert was playing outside when he came across a horse-drawn rolley being loaded with beer barrels.

He playfully hung to the back of the rolley as it began its journey past the Pit Heap. Suddenly, tragedy struck, and Robert's pained screams were bloodcurdling. His legs had become entangled in one of the large wheels of the rolley and caused devastating injuries. One leg had been completely crushed to the thigh, and the other was badly broken. The rolley was instantly halted and a witness rushed to fetch Dr Bradley. Unfortunately, one of Robert's legs was so badly damaged he needed to be admitted to Palmer's Memorial Hospital.

The hospital had been founded in the memory of Sir Charles Mark Palmer's wife, Jane, who often worried for the poor who lacked adequate healthcare in Jarrow. Jane's death in 1865 was a saddening affair for her family and they

An example of a horse-drawn rolley. (Source: Julian Harrop)

J. D. Rose's photo of Palmer's Memorial Hospital. (Source: Kevin Blair, Phyllis Claxton and James Rose)

wanted to keep her memory alive. Her selfless wish to help others resulted in a building being built that saved thousands of lives. The hospital had eight iron bedsteads and there were coal fires to keep the rooms warm. Venetian blinds hung in the windows and bedrooms for the matron and house surgeon were furnished with Kidderminster carpets, a table, a washstand, a chest of drawers, a looking glass, and venders and fire iron. Fire scuttles were also ordered along with suitable furniture for the servants' rooms. The building was insured for £2,000, and the fixtures and fittings for £500. After writing to various medical institutes across the country, Mrs McGregor was employed as the matron and would be paid £30 per annum. Mr W. J. Butler of St Mary's Hospital, London, was appointed as the house surgeon at the cost of £70 yearly. Local Jarrow doctors were asked to provide their services at a fee and were given seven days to reply to the offer.

Palmer's Hospital was funded by donors formed in subscriptions, such as a payment from the Engine Works of Jarrow of £47 16s 6d that was added to the hospital's account at the Newcastle branch of the National Provisional Bank. The generosity of many helped save Robert Campbell's life. The operation to amputate the crushed leg was performed by Dr Bradley at Palmer's Memorial Hospital with the assistance of Dr Haynes. Robert survived the shock and pain of losing a leg, but his life would never be the same again.

WANTED, for the Cottage Hospital at Jarrow, a MATRON, who has had previous hospital experience. —Apply by letter enclosing testimonials, addressed to WM. THOS. NEWMARCH, Hon. Sec., of the Committee, Quayside, Newcastle.

An advert printed in the *Newcastle Daily Chronicle*, December 1870, in search of a matron for the new hospital. (Source: *Newcastle Chronicle*)

On 25 February 1886, Robert and a boy named Peter Brizland were loitering close to Palmer's Drafting Office. Brizland handed Campbell a box of matches. As Brizland went home, Campbell lit a match and threw it up the spout smoke at Palmer's. Sparks flew and a small fire erupted as the panicked Robert attempted to put the flames out, but failed to do so and ran away instead. Eliza Crawley, aged eight, and Mary Lindsay, aged ten, had witnessed the fire start and ran to the Whalen house at Palmer's Place. Catherine Whalen, PC Whalen's wife, rushed to tell the gateman and raise the alarm. The fire was extinguished but the flames had already damaged the spouting and roof.

PC Whalen apprehended the boys and Robert admitted setting the fire. They were summoned to police court where Mrs Campbell stated her son was out of control and behaved very badly. Brizland's mother spoke favourably of her son and even Revd W. J. Burn was called to praise Brizland's behaviour because the boy regularly attended Sunday school. Brizland was subsequently dismissed from the court as doubt was raised over his part in the fire.

On 4 March, Robert returned to Jarrow Police Court to learn his fate. With his mother once again reaffirming that he was uncontrollable and badly behaved, the magistrates took a dim view of him.

Mr Johnson said, 'If he had two legs, we would have been able to deal with him, but he has only one leg, and therefore we cannot get him placed in an industrial school. Because he has only one leg you wish us to be severe.'

'If he had two legs, I should have appealed to you in the same way,' Mr Newlands, prosecuting, replied.

Questioning the mother again, Mr Johnson asked of Robert, 'Has he a mania for setting things on fire?'

'No, he never did anything like this before,' Mrs Campbell answered.

As Mr Newland complained if they imposed a fine it would punish the parents and not the boy, the magistrates made their decision. Arson was a serious crime and Robert was incredibly lucky to be discharged from court after he promised to attend school.

Following the loss of his father, Robert left school and worked in the shipyards. In March 1889 he was walking across scaffolding at Palmer's of Howdon when he slipped and fell a great distance. He suffered wounds to the head and face and was lucky to be alive, and still returned to the shipyards soon afterwards.

After breaking into the office of the Tyne General Ferry Company at the boat landing in Jarrow, stealing tobacco, cigarettes, cigars, pipes, two tobacco boxes

The Jarrow Ferry Landing – close to the spot where Robert Campbell began his short-lived career of theft. (Source: Natasha Windham)

and some copper, Robert and his friend George McIntosh were apprehended. Sergeant Nicholson arrested Campbell at his mother's home in Ellison Place. Nicholson searched him and found a tobacco box, seven packets of cigarettes and a pouch of tobacco in his pockets. After searching the yard, Nicholson also found more packets of tobacco hidden under a staircase. Escorted to the police station, and in the presence of McIntosh, Nicholson asked Robert if he was guilty. 'Yes, that's right,' Robert told them.

Robert and a man named Thomas Murphy were also charged with breaking into John Gould's shop on Clayton Street and stealing money. They also stole a coat with a key in the pocket and a jar of pickles from Mr J. B. Slevin's shop on Ormonde Street. At the Epiphany General Quarter Sessions of the Peace for the County of Durham in early January 1890, Robert, aged sixteen, was sentenced to nine months' hard labour. Seventeen-year-old George McIntosh was sentenced to six months' hard labour and Thomas Murphy, fifteen, to ten days' imprisonment with further three years in a reformatory.

Robert's heart, though, wasn't in a prison cell or working as a labourer. He wanted to be on the stage. It's unknown how he first secured his big break, but his wish was about to come true. A benefit concert was held at the Co-operative Hall in Jarrow in January 1896. In the second half of the show, Robert took to the stage in front of a meagre crowd. Described as a 'champion one-legged dancer' he sang and cavorted his way into the hearts of the audience. As he finished his act, his new fans rose to their feet and heartedly applauded. He must have felt a rush of pride as he left the stage.

He had discovered a new passion that would blossom into a promising career. In 1902, he was now a beloved local entertainer and musical hall artiste.

Bob Campbell, the 'champion one-legged dancer' of the North East. (Source: Allison Jones)

In August of that year, a benefit concert was held in the Palace Theatre in his honour. Acts such as Rhoda Paul, the child comedian and singer, Madame Lamb and the thirty singing children, and J. W. Haywood and his three performing dogs provided entertainment to a large and appreciative audience, and it was later described as the greatest concert ever held in Jarrow.

In 1922, the *Perthshire Advertise*r said of Robert Campbell, 'an eccentric comedian, who claims to be a champion one-legged dancer, is also to appear. This feature of the programme should be thoroughly enjoyed as a novel and interesting display of what can be accomplished on one leg.' He starred in the Comedy Theatre in November 1917, where the *Shields Daily News* said, 'Bob Campbell is full of jokes about himself and everything else he can think about, and his dancing is really clever.'

By 1939, Robert was somewhat retired and lived with friend Eddie Clarke at No. 23 Walter Street. He had maintained one small link to his murky past and collected smoking pipes as a hobby. Sadly, in 1947, he was admitted to the Little Sisters Nursing Home in Sunderland. He passed away on 23 January 1956, aged eighty-two. Bob Campbell had truly learnt a valuable lesson during his lifetime. No matter how many mistakes he had made in life, he could always strive to become a better person and would one day be affectionately known as 'Tyneside's favourite comedian'.

NOT LIKELY TO BECOME AN EFFICIENT SOLDIER

Courage isn't a virtue or skill we're born with; it's strength of character that is forged in our hearts when we face our greatest fears and choose to conquer them. Ralph Scanlan, an ordinary Jarra lad, was emboldened by his acts of heroism but wounded by his exposure to death, trauma and gunfire. The First World War damaged him deeply, but his love for his hometown continued to flourish.

Ralph Scanlan was born in Jarrow in 1897. He was the youngest child of Alfred Scanlan and Ann 'Annie' Dunn. Like many young men in 1915, he wanted to enlist in the armed forces as he believed it was his duty to his country. Ralph was 5 feet 2 inches and weighed 11 stone 5 lb. He was an unmarried labourer whose next-of-kin was his mother. His desire to join the Northumberland Fusiliers was rejected due to his apparent 'poor physique'. The enlistment papers were stamped officially with the following words: 'Not likely to become an efficient soldier.'

Once the war machine was in full force and allied troops were being slaughtered in great numbers the Ministry of Defence relaxed their strict rules regarding efficiency in soldiers, and Ralph joined the Durham Light Infantry where he bravely fought in the trenches of France and Flanders. He was wounded several times in action and spent two months in a venereal hospital in Newcastle upon Tyne before he escaped from the ward and returned home to Jarrow.

It was mid-October 1918 and Ralph was a wanted man. His appearance and no doubt his demeanour had changed significantly since serving in the army. The right side of his face was now scarred, caused by a bullet injury inflicted during his time at the front. He was an absentee from the DLI and the local police force were ordered to keep a sharp eye out for him.

He evaded arrest until the week of 18 October, when he was caught by a police constable and taken to Jarrow Police Court. He was escorted back to Brighton Grove Hospital in Newcastle, but days later he once again escaped and returned home to Jarrow. With his mental state frayed and ravaged by war, all he wanted to do was spend time with his family and friends, but it wasn't meant to be.

On 23 October, Ralph had been spotted by Detective Sergeant Wood. Ralph, along with another soldier named M. Nee, were boarding the Jarrow to Howdon ferry across the River Tyne. It was half past four in the afternoon as the frowning sergeant followed them onboard the ferry and waited for the appropriate moment to arrest the absentee soldier.

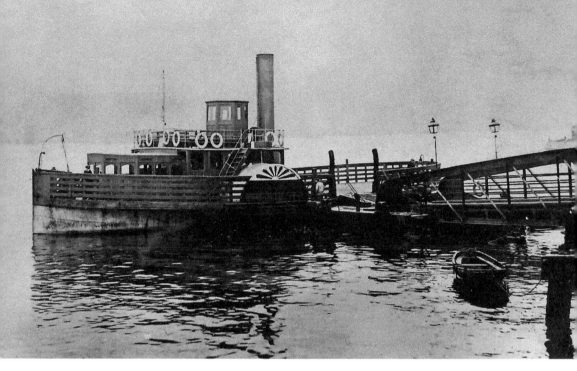

Where Ralph was first spotted, the ferry landing at Jarrow. (Source: George Nairn)

As the ferry crossed the river, the two soldiers noticed Sergeant Wood was watching them. Ralph, followed by Nee, hurried to the stern of the boat with Wood close behind. As Ralph climbed onto the rail, his friend encouraged him to jump. 'Go on, Scanny!' Nee shouted. 'Dive in; make a cut for it! I will follow you!'

Detective Sergeant Wood bellowed at them not to be so foolish. He darted towards Ralph to capture him, but he was too late. Ralph jumped overboard just as the sergeant reached for his arm.

The ferry was halted, and two life belts were thrown to Ralph, who was battling to stay afloat in the freezing conditions. The strong tide and icy temperatures hampered his efforts and moments later he sunk in the water. A search was conducted to find the missing soldier, but the darkness hampered what little could be done. Almost a month later, on the 19 November 1918, the River Tyne Police recovered Ralph's body from the river near Palmers Shipyard in Jarrow.

Private Ralph Scanlan's fateful actions that windswept evening had been blamed on him wanting to evade arrest, but nobody considered the mental scars he had suffered fighting for his country. He was a young man who had risked his life countless times on the battlefield, only to perish in a river close to his home. He proved beyond any doubt he was a capable and efficient soldier and will hopefully be remembered for his courageousness. At the age of twenty-one, he had truly faced his fears and now rests peacefully in Jarrow Cemetery.

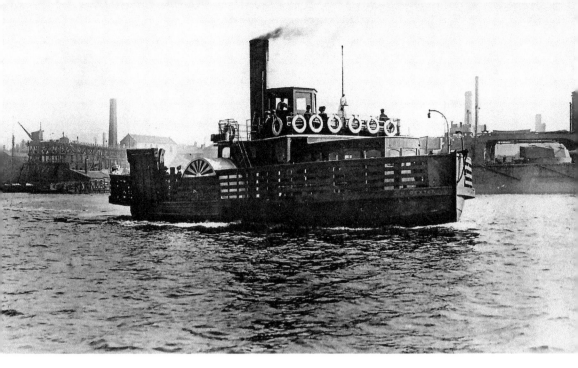

Above: Ralph's last journey on the Jarrow to Howdon ferry. (Source: George Nairn)

Right: Private Ralph Scanlan's grave at Jarrow Cemetery. (Source: Ewen Windham)

WHERE'S YOUR WIFE?

Jarrow was still the wild west of the North East and testosterone often mingled with the temptation of a tipple or two. A day's work in the shipyards, iron or chemical works was tiring and fraught with danger. 'Health and safety' were words in the dictionary, not guidelines to follow at your workplace. Your family depended on you to earn your wage and spend it wisely. A roof over your head and food on the table would keep the wolves of the workhouse at bay, but they were a constant threat.

It was a time-honoured tradition for many a man to drink when the working day was done. Some were teetotal, others raised a glass once a year, and there were those who battled with sobriety. Patrick Mannion was an Irishman shackled by his impulse to drink. He was born around 1876 in Galway, Ireland. Living with his sister, Bridget, in Jarrow, he was an ironworker and a persistent brawler. On the night of 16 September 1899, Patrick was walking to the Grange Hotel drunk and spoiling for a fight. At 8 p.m. Thomas Cullen entered the bar and asked the manager, George Moffat, for a glass of beer. Moments later Patrick joined them and asked for a drink, but a barman refused to serve him. Thomas was sitting at a table with his beer as he and Patrick began to argue.

One of the many pubs in Jarrow – The Ben Lomond. (Source: George Nairn)

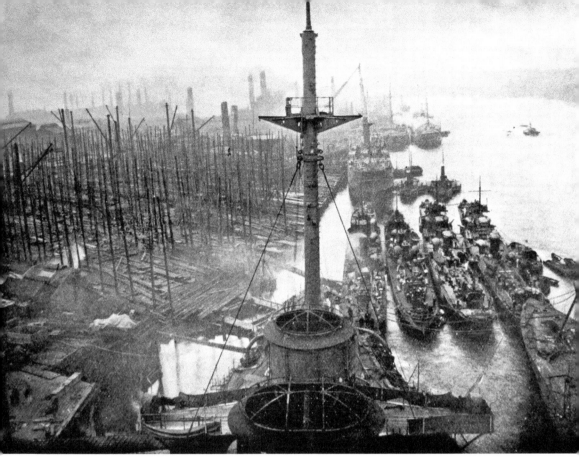

More than half of the male population of Jarrow were employed at Palmers Shipyard. Photographer: J. D. Rose, 1899. (Source: Source: Kevin Blair, Phyllis Claxton and James Rose)

The manager intervened and told them if they wanted to fight, they had better leave, or he would throw them out.

Mannion left the bar first and waved his hand at Cullen. He wanted to fight. Cullen then followed him onto Gray Street. Thomas was sober, but Patrick wasn't. Standing in their fighting positions each man eyed the other. Suddenly they raced toward each other and Mannion, who was a powerfully built man standing over 6 feet tall, seized upon Cullen and threw him to the ground. A fight commenced and eventually Cullen landed on the curb where Mannion kicked him several times. A crowd had begun to circle them as the violence continued. With his knees, Mannion slumped onto Cullen's stomach and squeezed the injured man's throat. With a wave of sudden awareness washing over him, Mannion stood and walked away, leaving Cullen in desperate need of a doctor. At least that's what two young boys reported witnessing.

The street was teeming with shock when Cullen was unable to stand. Four men carried him home to No. 17 Stead Street and another witness went to fetch Dr Bradley. At 10.50 p.m. Inspector Hildreth entered Mannion's lodgings on Albion Street. He found Mannion drunk and sleeping on the floor. Waking his soon to be prisoner, he asked Mannion to answer to the charge of assault.

'I know nothing about it,' Mannion had replied. The drunken brawler was taken into custody. The following morning he was charged with wounding Cullen.

On Sunday evening a statement was taken at the bedside of Cullen as Mannion stood in the room beside Inspector Hildreth. Councillor Pearson was also present. Cullen said, 'On Saturday night between 7 and 8 p.m. I was in the Grange public house. Accused was in the bar going about wanting to fight anybody. I came out. Accused followed me, started to hit me, and knocked me down with his fists. When I was down, he kicked me between the shoulder blades. I was carried home by four men. I did not want to fight him; he was too big for me.'

Thirty-six-year-old Thomas Cullen passed away the following morning at 9 a.m. Dr Bradley examined the body of Cullen and an autopsy was performed. The body was unmarked and the organs were healthy. The spinal cord was torn, and the fourth vertebra fractured. Cullen's back had been broken during the fight. The witnesses, however, couldn't agree how the struggle had transpired. All said Mannion had started it, though some said Cullen had first knocked Mannion to the ground. The two young boys, though, told the magistrates of Jarrow Police Court that Mannion had first knocked Cullen over.

Thomas Cullen was buried in Jarrow Cemetery, though the whereabouts of his grave is unknown. (© Natasha Windham)

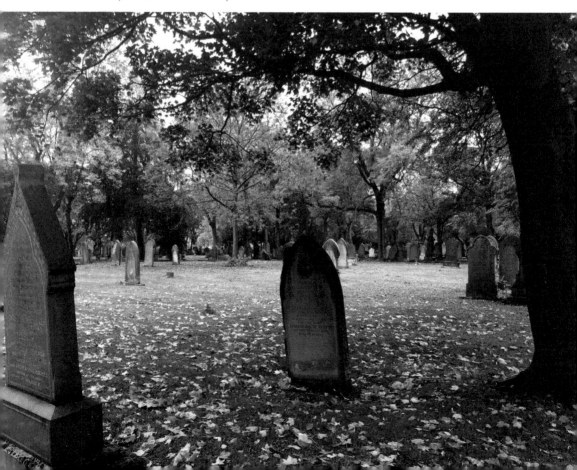

Harry Norris, a boy of fourteen, told the court Mannion was 'full up'.

'By "full up" what do you mean?' Coroner Graham asked.

'Drunk,' Norris swiftly replied.

'It is very expressive,' the coroner admitted, telling the boy he was free to leave the witness box.

The jury retired after a considerable time debating the case, they returned a verdict of murder against Patrick Mannion. Days later, Mannion was once again present at the police court. The witness statements still differed, not agreeing to who left the bar first or who started the fight. The charge was eventually reduced to manslaughter and he eventually stood trial at Durham Assizes where he was sentenced to nine months' imprisonment.

In 1901, Patrick was charged with being drunk and disorderly on Monkton Road. Mannion had been darting across the street damaging items outside a shop and had upturned a wheelbarrow containing a large quantity of groceries and eggs belonging to grocer J. H. Ghould. Five shillings worth of goods had been damaged and Mannion had been swiftly arrested by Sergeant Padden. Accused of possessing a 'very bad character', Mannion was fined 40s and costs.

By January 1906, Mannion and his neighbour James Cunningham were accused of fighting in the back of Albion Street. As soon as they spotted Sergeant Binns they went indoors, waited for him to leave and then went outside again to resume their fight. Cunningham was fined 10s. Mannion was fined 20s.

Patrick's fell into further hot water in October 1909. During a football match at the Jarrow Caledonian's football pitch on Curlew Street, Patrick had stormed

A hand-tinted postcard of Durham Gaol. (Source: George Nairn)

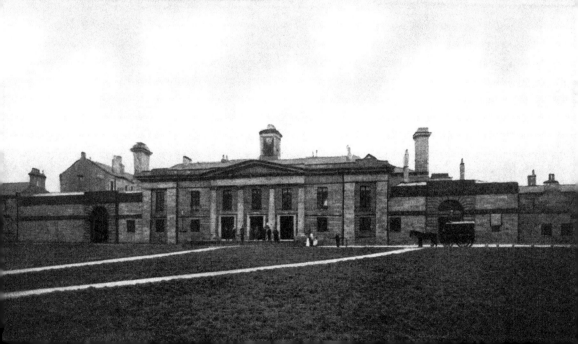

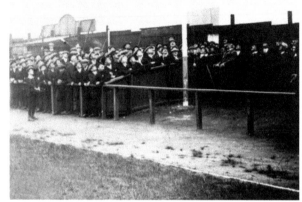

Left: The Jarrow Caldedonians football ground, Curlew Road. (Source: the archive of Patrick Brennan's local history website www.donmouth.co.uk)

Below: Lord Northbourne, watched by the mayor, kicking a ball at the Jarrow Caledonians ground at Curlew Road. (Source: www.donmouth.co.uk)

onto the pitch and started a fight. Normality was soon resumed, but heavy rain brought the game to a halt.

Mannion then created an even bigger disturbance and threatened to break down the cabin the footballers were using as shelter. He was summoned to police court but vanished from Jarrow soon afterwards. Six months later he was arrested in South Shields and fined 40s and costs.

Alcohol could be friend or foe of the Jarrow man. As PC Wise would attest to, it sometimes brought him cases of a more amusing nature. As he walked along Albert Road one late evening in October 1889, he crossed into Humbert Street. John Patterson, Thomas Patterson and John Sparks were running up and down the road, hurling flour at each other. Boisterous, drunken flour throwers weren't to Mayor Berkley's taste and he fined the culprits 5s and costs each or seven days in prison if they were unable to pay the fine.

PCs Garbutt and Marshall would warn you of the dangers when attempting to arrest a gravely drunken man who wished to smash furniture. On the night of 1 October 1889, Bernard McGhee had lost his mind to drink and was trashing the inside of his home on Monkton Road. Hearing the disturbance, Marshall and Garbutt entered the house and climbed the staircase. McGhee ran towards the

Curlew Road, November 2019. (© Ewen Windham)

The scene of the flour fight, Humbert Street, Jarrow, December 2019. (© Ewen Windham)

police constables, seized Garbutt by the front of his uniform and threw him down the stairs. Garbutt was knocked unconscious and Marshall, now alone, had to arrest the dangerous man. Alderman Dickinson lectured McGhee in the local police court and fined him 5s and costs for being drunk, 20s and costs for assault, and ordered to pay a further 15s and 10d damage to replace the policeman's cape.

The more mundane crimes were just as common in Jarrow. John Windham, a local cartman, and the son of a railway policeman, discovered this to his hindrance. He was charged with furiously driving two horses and a cab along Ormonde Street on 23 February 1883. Sergeant Boiston proved the case at police court and John was fined 2s and 6d plus costs. Often chased by the Inland Revenue, John was at least lucky in love. He adored his wife Jane, though often suffered money trouble, which meant he was unable to pay the general district borough rates for the stable he rented at Red House Farm.

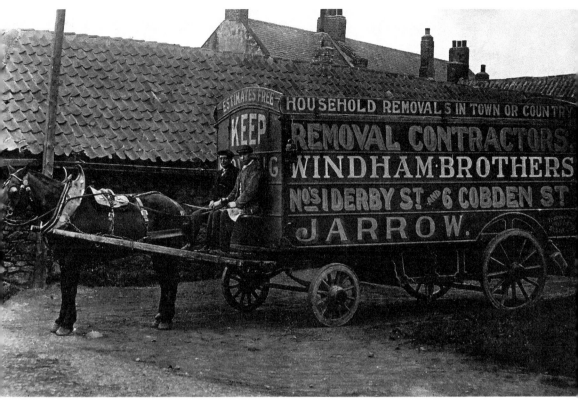

The Windham brothers, John and Joseph. (Source: George Nairn)

Joseph Windham, the elder brother of John, was also no stranger to police court. In September 1903, he was called as a witness at the inquest into the death of William Thomas Forster. The deceased had been killed near the electric power station at Palmers Works. Joseph was on the jetty near the circulating pump house the morning of William's death and had heard a shout. Looking through the house window, he saw William lying on the floor with his right hand on the terminal of the starting switch. Joseph ran as fast as he could to find the electrician, William Newson, so the current could be turned off. They tried in vain to resuscitate Forster but unfortunately it was too late. Despite the dead man's demise being the result of a workplace accident connected to him slipping on the floor and knocking against a live terminal with a voltage of 440, a verdict of accidental death was returned.

By October 1904, Joseph was now butting heads with his landlord Dr Bradley and the justices at Jarrow Police Court. He was summoned for refusing to pay borough and general district rates on a property on St Paul's Road. Joseph stated that Bradley, the owner of the property, had agreed to pay said rates. Dr Bradley, who was also a member of the justices that day and sitting on the bench, denied this. He explained the house on St Paul's Road had a stable attached,

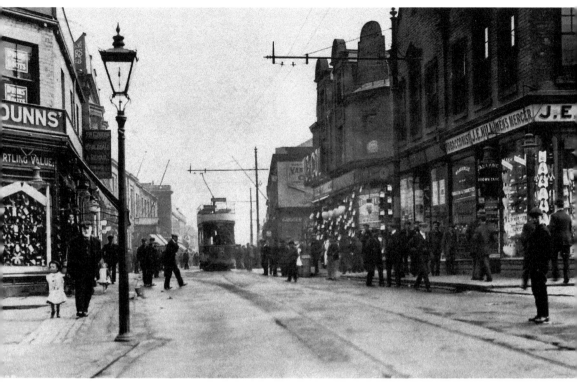

Ormonde Street, Jarrow. (Source: George Nairn)

which was occupied, so he too wouldn't pay the rates. He had only allowed Windham to rent under the promise the stable wouldn't be used. As there were ten hens in the stable, that meant it was occupied. Joseph was ordered to pay 8s 4d.

Still, alcohol sometimes sent a chill across the spine of the ordinary Jarrow man. Peter Kane, born in 1893, liked to celebrate. He was a boxer with a ferocious punch and eye for trouble. If he wasn't battling his mother, he was struggling with the police. In April 1920, PC Murdock saw Kane on Ormonde Street and knew there was a warrant for the boxer's arrest. After being stopped and asked to accompany the officer to the police station, Kane had thrown off his coat and said, 'You will have to carry me.' After violently escaping the constable, he ran through North Street but was captured by PC Usher.

Often leaving broken glass and fractured family ties in his wake, Kane was a good father and skilled sportsman who was known as 'The Tank'. During his time in the First World War, he was captured by the Germans and held in a prisoner of war camp where he was able to fight in boxing matches where the prize was a food parcel. Each time he won, Kane would distribute the food to his fellow soldiers. Superintendent Yeandle once said, 'Kane practically lives by fighting,' but what he didn't realise was that was precisely what saved hundreds of soldiers in a prisoner of war camp from starving to death.

Men were said to be gruff and hardworking with little time to spend with family. They were drinkers, gamblers, brawlers and fighters, but when have newspapers focused solely on the positives? John Crow, in 1889, wept over his wife's drunkeness as she once again stood trial for theft. After the loss of his own wife in 1891, John Windham focused on raising his three young sons and never remarried. The two Pattersons and Mr Sparks never fought with flour again. Patrick Mannion left Jarrow and returned to Ireland because even his own sister was afraid of him. Joseph Windham celebrated his twenty-fifth wedding anniversary on Christmas Day 1905. PC Garbutt continued to be assaulted in the line of duty, and Peter Kane resumed his career as a local boxer. The working-class male in the Victorian and Edwardian period wasn't a stereotype; he was a hard worker. He returned home each evening with his pay in his pocket and his clothes dusted with dirt, soot or debris. His muscles ached, his feet were tired, but his cap still rested neatly upon his head. The reliable and industrious Jarrow man paved the way for a revolution and we, the people, thank him for his hard work.

CONCLUSION

Victorian Britain, and Jarrow in particular, would have been a formidable and daunting place to live. While the founders of large businesses grew in wealth, their employees struggled to make ends meet. Doctors' fees were chargeable to patients and if you ever had the misfortune of being placed in a workhouse or asylum you would also be expected to pay towards your own maintenance.

The Edwardian period was just as austere but Jarrovians still found ways to entertain themselves. Often their day-to-day lives were ingrained in survival but enriched by family, business, or friendship. Theatres, football matches, parades and pubs brawls were part of the fabric of daily life and crimes were still committed at an alarming rate.

Despite the shortcomings of the past, the characters of those long-forgotten days still possess the power to shine through. Their sparkle doesn't diminish because they have died and as this book reaches a conclusion, it is only fitting to once again delve into the life of James Dudfield Rose.

He was content in his old age and occasionally discussed the resistance he had often faced as a councillor. He had once fought ferociously in a battle of words to secure extra beds for Jarrow's tuberculosis patients. 'Through the efforts of the late Alderman Armstrong we became subscribers for one bed at the sanitorium!

Children playing on Nansen Street, Jarrow. Photographer: J. D. Rose. (Source: Kevin Blair, Phyllis Claxton and James Rose)

Right: J. D. Rose's photo of St Paul's Road, Jarrow, in 1901 shows that building giant bonfires was another Victorian pastime. (Source: Kevin Blair, Phyllis Claxton and James Rose)

Below: J. D. Rose's coronation of Edward VII. Jarrovians in 1902 celebrating at Park Road. (Source: Kevin Blair, Phyllis Claxton and James Rose)

One bed! ... I was not content with one bed and fought for another against bitter opposition. Alderman Hall and Alderman Gordon are the only two left who will remember my diagrams which gave much offence to the opposition! After long debate we numbered thirteen and the opposition ten. One can hardly realise today that ten members of the council would object to pay for two beds in a tuberculosis sanatorium!' he had told an audience in 1935.

He was a determined and resourceful man who took great pride in his photography. Once he lost his hearing at an advanced age, the local police constables often closed the roads so he could safely travel home. His wife, Mary, would be waiting patiently for the sounds of his vehicle on Croft Terrace. As soon as she heard him approaching, she would throw the garage doors open and step aside.

J. D. Rose, photographer, standing on the roof of a taxicab on Tyne Street, Jarrow. (Source: Phyllis Claxton and James Rose)

In 1899, he had said, 'Can any of us believe that a nation is safe, or that it can ever be pre-eminent either in virtue or achievement which has not for its base a thoroughly educated intelligent people, constantly increasing in knowledge of the laws which govern human society?' His remarks, Victorian in their nature, share the sentiments of the time. Crime was often linked to absence of education, and Rose used this notion to his advantage when attempting to secure the Free Public Library.

James Dudfield Rose was, of course, a man created to debate and crusade for the rights of the poor. He passed away in 1947, but his memory lives on through his dedication to the town and its people. His final resting place is in the peaceful grounds of Jarrow Cemetery where many of the stars of this book were buried. Jarrow was once a town where in 1888 Thomas Whittaker was charged with being drunk and disorderly, though assured the magistrates he was merely

Children playing in the lane behind Croft Terrace, Jarrow. The little boy in the middle padded with clothing is J. D. Rose's young son James. Once again, the photographer is J. D. Rose. His wife, Mary (left), watches their son play. (Source: Phyllis Claxton and James Rose)

suffering from political excitement. It was a town where Minnie Potts, in 1882, had drunkenly chased her husband along the street with a large crowd following them until a surprised Sergeant Hedley had stumbled across the scene. It was a town where in 1889 Francis Stokes, aged seventeen, was sent to Durham Gaol for seven days' hard labour because he had eaten three work colleagues' breakfasts at Palmers Works. It was also the town where thirty-four-year-old James Boston, in December 1889, had been found living in a pigsty because he was destitute. James had crawled on his hands and knees to PC Walton because he was too exhausted to walk. The police constable had helped James to his feet and gently guided him to the relieving officer's house. 'Do you want something to eat?' the police constable had asked. James declined and moments after arriving at the home of the relieving officer he passed away. Their voices are now silent, but local history only dies if we forget about the people who once walked the cobbled streets of Jarrow.

J. D. Rose's headstone in Jarrow Cemetery, December 2019. (Source: Ewen Windham)

ACKNOWLEDGEMENTS

I'm eternally grateful to James Rose and Phyllis Claxton for allowing me access to their family archive. Thank you to Stewart Hill of the Friends of Jarrow Cemetery for the tour, George Nairn for permission to use photographs from his collection, and Debra Picken Nudd for creating the Facebook group Jarrow Memories. Thank you to Patrick Brennan of donmouth.co.uk, Kevin Blair of Facebook's South Tyneside's History in Old Photos, Julian Harrop of Beamish, and Trevor Hay, Allison Jones and Ewen Windham for permission to use photographs in their possession. I'm indebted to my late grandad who shared his love of history with me and I thank Nick Grant and Jenny Stephens from Amberley Publishing for their continued support.

Every attempt has been made to seek permission for copyright material used in this book. However, if we have inadvertently used copyright material without permission/acknowledgement we apologise, and we will make the necessary correction at the first opportunity.

ABOUT THE AUTHOR

With a keen interest in crime during the Victorian period, Natasha Windham has spent many years focusing on the history of Jarrow because of her familial ties to the town. Her paternal grandfather, Jim Windham, was born in Jarrow in 1920 and began his career at the age of fourteen delivering telegraphs to ships along the River Tyne. He retired from his position as the postal inspector of Jarrow aged sixty, and once wrote, 'We celebrate a family's unity, achievements, good fortune, and for our youngest members of the clan their promise, dreams and hopes. Life is a very winding trail indeed but in spirit we will be with them every step of the way.' Since his death in 2017, Natasha has delved further into Jarrow's past and has discovered countless tales of tragedy that often evoke the words of her grandfather. Life was indeed a winding trail for many, and she believes their stories need to be told.